historical
FICTIONS

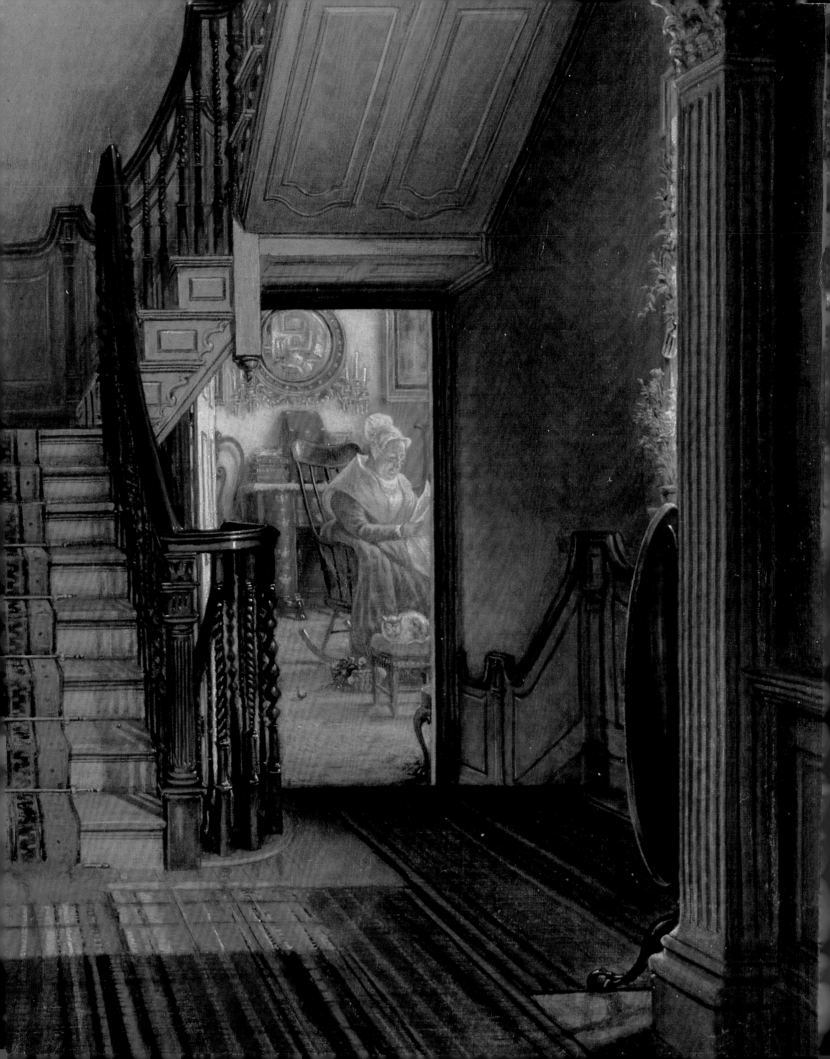

historical FICTIONS

Edward Lamson Henry's Paintings of Past and Present

AMY KURTZ LANSING

Yale University Art Gallery, New Haven, Connecticut
2005

DIRECTOR'S FOREWORD

The Yale University Art Gallery is pleased to present *Historical Fictions: Edward Lamson Henry's Paintings of Past and Present,* an exhibition that breaks new ground by restoring to the artist's works an understanding of the late-nineteenth-century American context in which they were produced. In the wake of the Civil War, Henry's romantic historical paintings used the past to address the country's current social, economic, and political tensions. His intimate domestic scenes and larger public canvases convey the crucial role assigned to history in the effort to construct a stable national identity. Amy Kurtz Lansing, a talented doctoral candidate in the History of Art at Yale and the Marcia Brady Tucker Curatorial Research Assistant in American Paintings and Sculpture, has organized this exhibition and written the catalogue, which derives from her dissertation. Her project extends Yale's tradition of supporting new research about American art through the work of young scholars. *Historical Fictions* would not have been possible without the generous participation of our lenders, to whom we are grateful for their willingness to contribute treasured works. The Gallery is especially grateful to Teri and Andy Goodman, B.S. 1968, for their partial and promised gifts of two paintings in the exhibition. Financial support for the exhibition was provided by the Friends of American Arts at Yale, the Eugénie Prendergast Fund for American Art given by Jan and Warren Adelson, and an endowment made possible by a challenge grant from the National Endowment for the Arts. The catalogue was generously supported by a grant from Furthermore: a program of the J.M. Kaplan Fund, and by the Virginia and Leonard Marx Fund. Each of these generous contributions affirms a collective dedication to innovative American art exhibitions.

JOCK REYNOLDS
The Henry J. Heinz II Director
Yale University Art Gallery

ACKNOWLEDGMENTS

Historical Fictions: Edward Lamson Henry's Paintings of Past and Present would not have been possible without the advice and encouragement of Helen Cooper and Robin Jaffee Frank, Curator and Associate Curator of American Paintings and Sculpture, whose assistance has been invaluable at every stage. Ronald Burch, of the New York State Museum, and Phillip Seitz, at Cliveden, a National Trust Historic Site, provided extensive research support, enabling the important discoveries presented in this exhibition. Further research assistance was offered by the following individuals and institutions: John Boos, Manoogian Collection; Gay Ellis; Dr. Russell Flinchum, Century Association; Eric Greenleaf; Tammis Groft, Albany Institute of History and Art; Lucy Lieberfeld; Schwarz Gallery; Emily Shapiro, Corcoran Gallery of Art; and Karen D. Stevens, Independence National Historical Park Archives.

I am profoundly grateful to the institutions who have loaned their works to the exhibition: the Addison Gallery of American Art at Phillips Academy, Andover, Massachusetts; the Albany Institute of History and Art; the Century Association, New York; the National Trust for Historic Preservation, Washington, D.C.; the New York State Museum, Albany; the Shelburne Museum, Vermont; and the Smithsonian American Art Museum, Washington, D.C. I am particularly indebted to Mr. and Mrs. Andrew J. Goodman, Mr. and Mrs. Frank L. Hohmann III, Richard Manoogian, and other private collectors for their willingness to part temporarily with paintings that they treasure. Special thanks go to Sandra Smith of the National Trust for Historic Preservation for facilitating the loan of a crucial work from its collection, and to Stephen Kornhauser for conserving it.

For making the exhibition and publication a success, I would like to thank the Gallery's resourceful and dedicated staff, particularly Senior Administrative Assistant Janet M. Miller, who tirelessly attended to myriad details, as well as Lynne Addison, Clark Crolius, Patricia Garland, Anna Hammond, Amy Jean Porter, Lesley Tucker, Marie Weltzien, and Janet Zullo. Robin Frank, Lesley Baier, and my dissertation adviser Alex Nemerov helped craft the text, and Jenny Chan created the book's sensitive design. From the beginning, Jock Reynolds's enthusiasm bolstered the project.

For their unflagging support and love, past and present, I dedicate this book to my family and my husband, Charles.

AMY KURTZ LANSING
Marcia Brady Tucker Curatorial Research Assistant

I hope to obtain all the likeness and information this time. for I shall not leave off till it is finished when I shall send on a photograph for your approval. I have dresses or at least can obtain them of the period I only need an old coat of the time swallowtail or frock it is all the same for I wish merely to get the effect of the narrow high collar sloping effect which I cannot do from a modern one. this is all. I dreamed the other Evening of ransacking through your old Garret with you amongst old chests in old presses and like all dreams. the imagination ran riot and I was bewildered with the most rare old costumes old china silver quaint singular specimens of Furniture. till they seemed Endless. and my wonder was why you never spoke of it as having such treasures up there before

INTRODUCTION
Historical Fictions

Widely appreciated in his own time as an artful storyteller, Edward Lamson Henry (1841–1919) portrayed places and events associated with early America and the Civil War. Henry's fascination with "historical fictions"—pictorial visions of historic sites and incidents—resonated with a large public concerned, in the aftermath of the war, with defining the country and themselves through an understanding of the past. Although precisely rendered, his paintings and drawings proffered fantasies of colonial America that addressed his viewers' concerns about their changing world, profoundly affected by mounting industrialization, urbanization, and immigration. Turning his eyes to contemporary America, Henry reinterpreted the Civil War's destruction and questioned the disruptive impact of modern technology, envisioning as alternatives the pleasures of antiques and the memories of country life. Whether in paintings of past events or present-day scenes that celebrated old furniture and architecture, historical fictions served a public and private need to establish a unifying identity and to engineer stability through the medium of history. Once dismissed as an inappropriately sentimental interest for a progressive country, the past now offered the promise of a harmonious present and future based upon shared memories; however, with the social order at stake, constructing a consensus about such recollections would prove challenging.

1

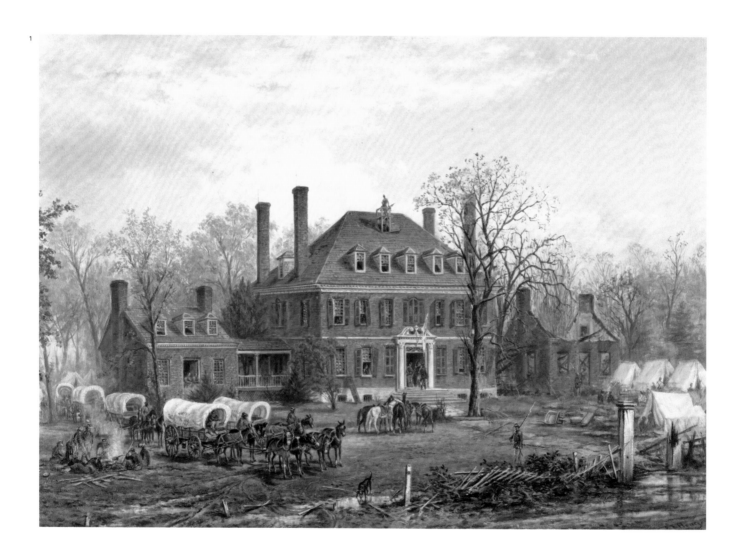

History Lessons: The Civil War

When first shots rang out at Fort Sumter in 1861, Henry was in Europe.[1] It was not until the draft riots of July 1863 that the war intruded upon his universe, as New York—to which he had recently returned—was riven by racial and class warfare that left dozens dead and the city's economic elites uneasy about reinstating the consensus essential to societal order. The events of that summer made an impression on Henry, who remarked in response to subsequent ethnic clashes in 1871, "I was very strongly reminded of 1863 by the appearance of the streets."[2] In the fall of 1864, recognizing the importance of documenting the war whose politics so affected the wealthy New Yorkers he sought as clients, and curious about the conflict's effects on the South—to which the Charleston-born artist had family ties—he traveled to Virginia to observe the Union Army's campaign along the James River near the Confederate capital, Richmond.

Henry served as a clerk on a Quartermaster's supply transport ship in October and November 1864.[3] In the growing tradition of reportage, he sketched the depots and plantation houses along the river, capturing the war's depredations. Because of its historical fame, Westover, the eighteenth-century Georgian mansion built as the

Byrd family's seat and seized by the Union, particularly attracted his attention (fig. 1); of all of the "gorgeous old Manors on the James River," he later declared, "that place set me nearly crazy."[4] Henry documented the house in a pencil and pastel sketch, which, though primarily focused on the mansion's revered and damaged architecture, carefully noted the distribution of soldiers' tents on the right (fig. 2).

Back in New York, Henry began *Westover, Virginia*, which he completed the next year (fig. 1). For an audience with an unprecedented visual awareness of the war instilled by magazine illustrations and stereophotographs of battle sites, Henry selected and portrayed Westover to dramatize changes to the country's financial system and culture, and the larger sacrifices necessitated by the conflict.[5] Although in Union hands, Westover was a plantation house and therefore a symbol of the Southern slave economy in which many wealthy New Yorkers had been invested before 1861.[6] The burned-out, moss-draped right wing and the fire smoldering on the left suggest the destruction of the South's plantation economy, but the house's core remains largely untouched. Its solidity forecasts a hopeful message of continuity and rebirth. Despite the pecuniary impact, Northerners recognized by the war's fourth year that the slave economy was an irredeemable ruin and that the financial system's viable remnants, like Westover in Henry's portrayal, would have to be repurposed for the benefit of the Union.

By depicting the house partially damaged, Henry was also acknowledging the immense sacrifices the war demanded in terms meaningful to his elite audience—who would mourn the damage to its refined architecture—and to the masses, who would sympathize with the devastation of a family's home. Such an overt illustration of the conflict's destructive impact signaled the Northern public's pained certainty by 1865 that the war must be won, even at the cost of honored portions of the country's

3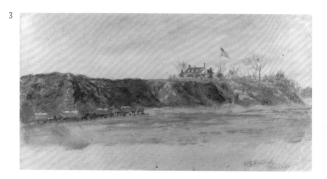

FIG. 3
City Point, November 1864
Oil on paper, 7 ¼ x 14 in. (18.4 x 35.6 cm)
New York State Museum, Albany

FIG. 4
City Point, Virginia, Headquarters of General Grant, 1865–73
Oil on canvas, 30 ⅛ x 60 ¼ in. (76.5 x 153 cm)
Addison Gallery of American Art, Phillips Academy,
Andover, Mass.

4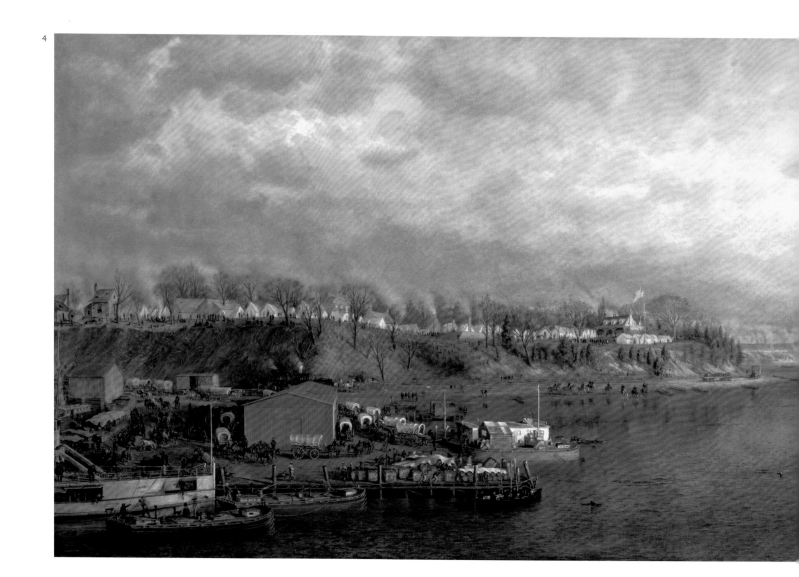

historical patrimony, or the loss of their own abodes. Westover's conversion from an icon of the Southern way of life dating back to colonial times into a weapon in the struggle for union is clear. From a vantage point closer than that of the sketch, the quiet bivouac of Henry's drawing, with its ghostlike figures, has been energized by the insertion of a departing wagon train, while sentries patrol the roof. Henry's target audience of wealthy New Yorkers embraced *Westover, Virginia*'s noble portrayal of the conflict's costs and sacrifices, accepting the painting in lieu of an initiation fee when Henry joined the Century Association, a gentlemen's club run by the city's artistic and economic elite, in 1866.[7]

Despite the conceivably divisive nature of Civil War scenes during Reconstruction, Henry's portrayal of City Point, another Union outpost observed during his Virginia trip, affirmed the ideal of an economically stable, socially cohesive nation. Strategically located on a peninsula between the James and Appomattox Rivers, City Point was commandeered by Ulysses S. Grant for use as a headquarters during the 1864–65 siege of Petersburg. As the center of operations for the Quartermaster Corps, which supplied an army of 100,000 from its shores, the once sleepy tobacco outpost became one of America's largest ports. City Point was the linchpin in Grant's system of communication with Washington, D.C., and the rest of the country. Painted from a boat, Henry's November 1864 oil-on-paper sketch of the site conveys little of its bustling character as the hub of the Union supply web (fig. 3). In a scene more reminiscent of the American West, a lone wagon train at the lower left inches past a high bluff, atop which we see isolated Appomattox Manor, the eighteenth-century seat of the Eppes family confiscated for use as General Rufus Ingalls's headquarters.

Begun before the war's end, *City Point, Virginia, Headquarters of General Grant* records activity at the front (fig. 4); but by its completion eight years later, the artist's rendering confidently asserted the means of Union victory—the extensive transportation network—as a new basis for national identity.[8] Deviating from his original sketch, Henry laid out an elaborate panorama

that emphasizes the convergence of barges, ships, wagons, and, most importantly, railroads at City Point. Strung along the base of the cliff, engines, box, and platform cars bearing heavy artillery illuminate the railroad's unprecedented strategic and tactical use in the Civil War. In addition, troops and horses arrive at the mail dock on the left, where the base's financial heart—the white-walled Adams Express Barge, through which tens of thousands of dollars and copious freight flowed each day—is anchored.[9] Next to it, laborers maneuver a coffin, a grim reminder of the war's deadly cargo, while on the right schooners wait to offload supplies to sustain the army's operations.

For audiences in the early 1870s, Henry's portrayal of the movement of goods and people underscored the war's dislocations, but his simultaneous emphasis on a tight web of communication and transportation celebrated the North's greatest wartime accomplishments: citizens banding together into a cohesive unit in America's moment of need, and the resulting physical and economic integration of the country. The technology that enabled the Union's triumph was subsequently applied to creating a transcontinental railroad in 1869, forging the country into an unparalleled financial and geographic power that was physically unified for the first time. Henry's glorification of the network at City Point resonated metaphorically with his audiences, who embraced the representation of efficient connections extending to Washington and beyond as a model for economic and social cohesion and the cornerstone of a common national identity.[10] The artist's decision to date the painting "65–1873" at the lower right, rather than simply noting the year of its completion, connects the Union's successful wartime formula of interdependence with the Reconstruction-era need to perpetuate the same sort of unity as a remedy for socioeconomic tensions like those that troubled Henry in the summer of 1871.

City Point, Virginia was purchased by New York's Union League, a men's club formed in 1863 to unify elites in support of a strong national state and to encourage the same sentiment in the masses. The group's conviction about the importance of merging Americans into a coherent populace, albeit one still governed by the wealthy, was based on the belief that a stable national government was essential to shared economic prosperity.[11] Through loyalty-themed publications issued during the war and the purchase and display of *City Point, Virginia* in the conflict's aftermath, they encouraged the development of "a healthy national sentiment" across all classes to forestall the kind of unrest that erupted during the draft riots of 1863 and again just before the painting's completion.[12] Much the way *Westover, Virginia* presented a historical monument's destruction to galvanize Union sentiment in a divided North, *City Point, Virginia* offered a paean to the modern mechanism of war, transforming it into a symbol of unity.

Historical Documentation, Preservation, and Re-creation

"Knowing the history of what one sees is perfect enjoyment."[13]

Edward Lamson Henry

"Bostonians!" implored a broadside published in June 1863, "Save The Old John Hancock Mansion. There is Time Yet."[14] Efforts to save the house of the signer of the Declaration of Independence and former governor of Massachusetts had begun four years earlier, when Hancock's descendants offered it free to the state on the condition that it be removed from the Beacon Hill plot sold out from under it. Opponents, wary of the landmark's elite associations, denounced as "sentimental twaddle" the expenditure of state funds for "an old building which is a curiosity merely because it is old."[15] But with the nation's plunge into civil conflict, the unifying value of history became more evident. Indeed, dawning recognition of history's ability to cement social bonds inflects the broadside's warning to the house's new owners: "we would admonish them how dearly is purchased any good thing which costs the sacrifice of public associations so dear and so noble as those that cluster around the Hancock House." Yet despite such impassioned calls for intervention, the public was unable to raise money to relocate the building, and the Hancock house fell under the crush of the wrecking ball in 1863.

The sensation caused by its demise inspired Henry to take up the subject two years later (fig. 5). With the war drawing to a close, the public was increasingly desperate to salvage historical patrimony as grounds for rebuilding an American identity. Many had procured relics from the house, or had articles fashioned from its wood—raw materials that became the building blocks of a poetic vision of the past that answered needs for reassurance about continuity with an earlier, less divided time.[16] Henry recognized that the house could serve as a powerful icon of unity because of its association with Hancock, who had "made of the alienated colonies of Great Britain a powerful, free, and for so many years a united people."[17] The public embraced his house as a symbol of commitment to the cause of freedom. Moreover, for those who had been displaced or suffered the death of family members, Hancock's venerable residence offered a vision of what they most hoped to regain. In Henry's portrayal, a man waits at the front gate while another descends from a carriage, reinforcing the notion of a return home.

Henry's efforts resonated with his country's emerging project of architectural, spiritual, and political reconstruction. As if to repair the "house divided," he centered the mansion on an unusual, almost square panel, calling attention to the balanced, symmetrical proportions of its minutely delineated Georgian architecture.[18] In composing a likeness that would promote the healing message of liberty and reconciliation, Henry likely drew upon literary and visual records of the demolished structure, such as Arthur Gilman's article, "The Hancock House and Its Founder," and a much reproduced woodcut by J. Davis.[19] He also owned a photograph of the residence, albeit from a lower, closer perspective than the painting, which he later inscribed, "The Hancock House. Taken down for a common modern house around 1865."[20]

Despite the availability of documentary sources, however, Henry crafted a romanticized portrayal, depicting the

5

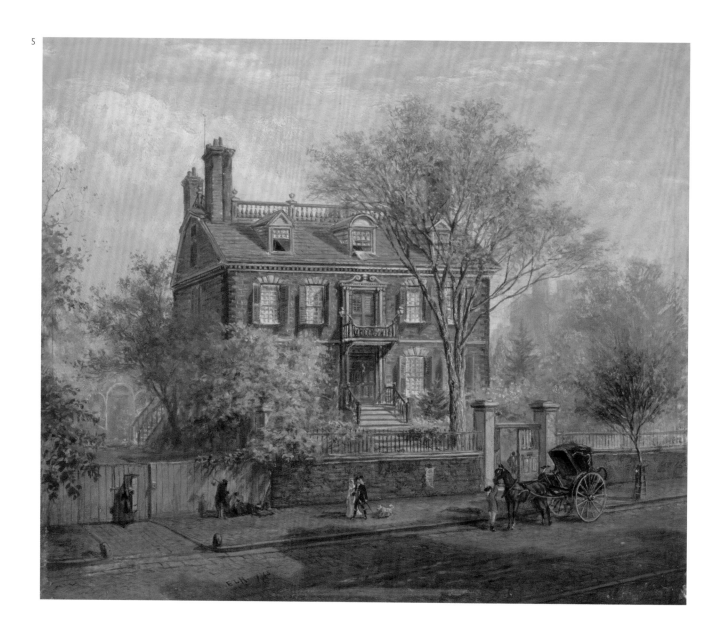

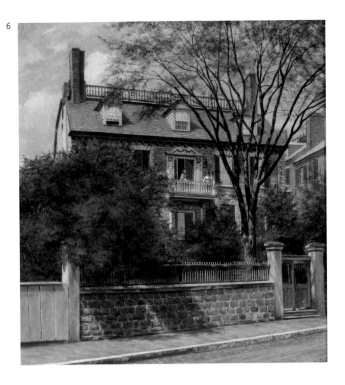

century-old building in its heyday rather than overwhelmed by the encroaching city. Comparison with William E. Norton's *A View of the John Hancock House*—painted on a panel salvaged from the home's parlor—underscores Henry's self-conscious avoidance of nineteenth-century urban discomforts (fig. 6). Norton faithfully replicated each detail of the photograph Henry also owned to empha-size the house's status as a relic. Henry—working partly from the same source—retained the factual aesthetic but selected a more distant vantage point that allowed him to exaggerate the house's proportions and isolate it amid extensive gardens, evoking its original, pastoral setting.[21] Only the area of deep shadow in the foreground, outlining the shape of chimneys and rooflines of buildings across the street, alludes to the city that had grown up around the house by the 1860s.[22] By eschewing strict adherence to the Hancock house's appearance at any one moment, Henry constructed a visual impression of permanence, striking a mood that is both antiquarian and poetic.

Although the Hancock house had decayed significantly in the years preceding its destruction, there is no sign in the painting of the "weather-beaten edifice" or other degrada-tions caused by age that afflicted the Pyncheon mansion in Nathaniel Hawthorne's *House of the Seven Gables*.[23] And while Hawthorne's tale of the corrosive legacy haunting the Pyncheon manor questioned the virtues of history and resi-dential permanence in the years before the Civil War, in the conflict's aftermath, Henry's *The John Hancock House* embodied the elusive stability that his audience sought in their own lives.[24] A tribute of 1863 describing the house's restorative potential evokes as well the mood of Henry's painting: "[We] pass up the worn gray terrace of steps, and in a moment more closes behind us the door that seems to shut us out from the whirl and turmoil and strife of the present."[25]

If Henry's depiction of a damaged Westover rallied support for the Union's preservation through the medium of a venerable building, *The John Hancock House* served as a memorial and a call to arms in the crusade for historic preservation after the war. The mansion inspired William Sumner Appleton, Jr., to found the Society for the Preservation of New England Antiquities (SPNEA) in 1910, one of the country's earliest such organizations. Appleton grew up on Beacon Street, only doors from the former site of the Hancock house, and his uncle installed its staircase in his country home. SPNEA's first journal issue featured a cover photograph of the Hancock residence subtitled, "The fate of this house has become a classic in the annals of vandalism."[26]

To broaden his painting's impact, Henry decided in April 1865 to display *The John Hancock House* at the annual exhibition at the Pennsylvania Academy of the Fine Arts (PAFA) in Philadelphia, where he had been embraced by the nascent preservationist community during his studies there several years earlier—the beginning of longstanding ties to the city.[27] His friend and former Philadelphia housemate William Kulp (ca. 1829–1870) brokered the sale.[28] Kulp was a noted antiquarian whose newspaper articles raised awareness of the need for historic preservation in the years preceding the Centennial.[29] A kindred spirit, Kulp exposed the young artist to what the former called "those gorgeous reliques that all the mechanic art of the day can never replace."[30] Through his friend's encouragement, Henry joined Frank M. Etting, chairman of the Committee on Restoration of Independence Hall, in refurbishing the landmark in the early 1870s.[31]

As early as 1866, the antiquarian enthusiasms that motivated many preservationists inspired Henry to sketch Kulp's federal-era hallway at 616 Spruce Street, a subject to which he returned several times over the next two decades in paintings like *Interior* (fig. 7).[32] To document the structure, Henry made a preparatory drawing of the stairhall, filling the sheet with carefully delineated architectural elements, inset details of carving, and notations about the number of stairs and panels.[33] The artist also employed a new tool in the antiquarian arsenal: photography. Just as he had earlier obtained a photograph of the Hancock house, Henry owned a picture of Kulp's stair landing (fig. 8). An amateur photographer himself, Henry knew numerous Philadelphia photographers, whose works he collected as inspiration for his history-inflected genre paintings.[34]

The same year that Henry sketched the stairhall, Kulp commissioned antiquarian photographer John Moran to shoot at 616 Spruce Street a likeness of his aged Quaker aunt, Hannah Tyson, the model for the elderly woman in *Interior*.[35] Moran may also be responsible for the picture of Kulp's stairhall, which clearly illustrates the window, architectural elements, and bust of the Apollo Belvedere present, in modified form, in Henry's painting. But while the artist echoed the photograph's composition, he substituted a Pennsylvania clock—perhaps drawn from his own collection of antiques—for the tilt-top table, and inserted an elderly Quaker to identify Philadelphia, the city the Religious Society of Friends founded, as the locale.[36]

Rather than faithfully re-create a federal-period interior in the antiquarian spirit, Henry evoked a sense of place and history through the people and objects associated with it. Such an untroubled fusion of documentary detail with romantic embellishments reveals his fluid, unsystematic approach to the past. Once identified, historical elements became a language that could be combined and reused, as Henry did several times with the stairway vignette.[37] In this way, the past was not the burden Hawthorne had feared,

but a malleable trove of allusions that, when combined in "historical fictions," provided a buoying sense of orientation in a changing world. To address the perceived rupture with the antebellum past, Henry converted *Interior*'s antiquarian armature into a reassuring image of historical continuity. The elderly woman's unreformed Quaker clothing is of a style more appropriate to 1840 than the 1880s, an anachronism that augments the aura of history already imparted by the neoclassical architectural details.[38] A coloristic and formal similarity between the bust—inspired by the Apollo Belvedere of the photograph—and the woman's bonnet links the two, one a symbol of classical and the other American antiquity. The statue serves as a sentinel of the stabilizing forces of culture and tradition. By positioning it atop the clock and shifting its orientation from profile to front, Henry projected the bust's message of historical continuity forward. The timepiece ticks on as the woman descends the stairs, moving from the house's garret toward its first-floor public spaces and, by implication, contact with the present. The Quakeress clings to the banister, a piece of her old house. Bolstered by the past, Henry implies, people navigate modernity and advance toward the future. *Interior* models the past's persistence, a tranquil ideal yearned for by Henry's public.

As the Centennial approached, public interest in the past increased, motivating Americans to inquire more deeply about its actors and to develop a malleable standard for historical authenticity that accommodated their concerns about social and political flux. The completion in 1874 of the last volume of George Bancroft's monumental *History of the United States*, published over three decades, provided the first overarching framework for understanding America's past. However, its emphasis on important men did not enrich comprehension of events outside of government and politics, a prerequisite for rebuilding emotional ties to the antebellum American legacy. In search of a way to rekindle the past in terms that would

FIG. 7
Interior, 1886
Oil on artist's board, 8 9/16 x 6 1/8 in. (21.8 x 15.6 cm)
Private collection

FIG. 8
Unidentified photographer, possibly John Moran
Stairway, City House—Built 1803
Albumen print, 7 3/4 x 5 3/4 in. (19.7 x 14.6 cm)
New York State Museum, Albany
(not in exhibition)

7

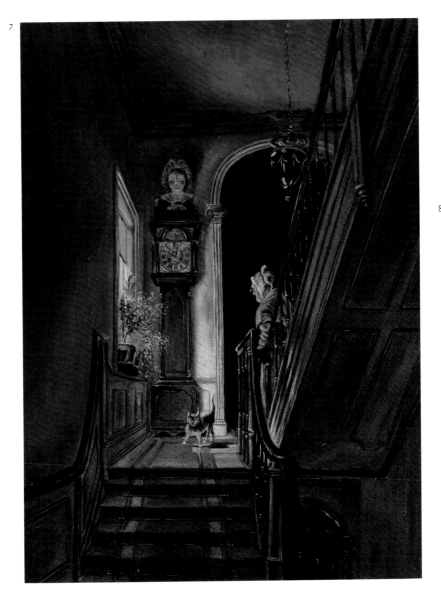

8

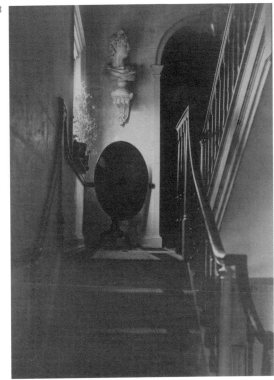

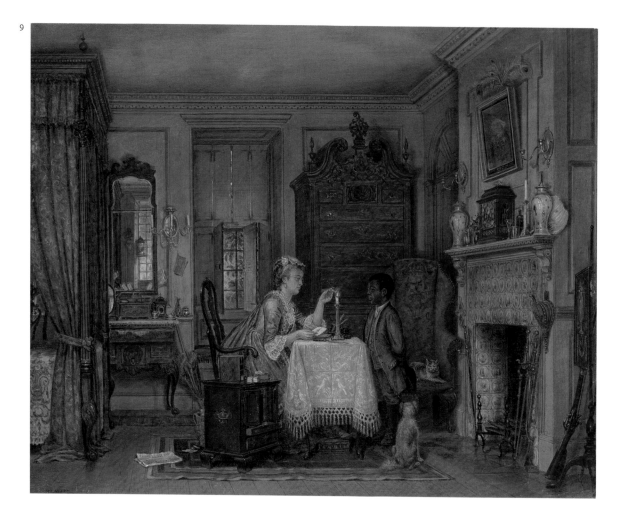

address contemporary needs for stability, Henry turned to Elizabeth F. Ellet's *The Women of the American Revolution,* a two-volume book that took the unusual step of examining women's roles in history through a series of biographical vignettes. In 1871, he based *Drafting the Letter* on Ellet's description of a Revolutionary War incident in the life of Philadelphian Elizabeth Graeme Ferguson (fig. 9).[39]

To reconcile warring sides—a motive compelling to postbellum viewers—Ferguson had approached American Colonel Joseph Reed about the possibility of abandoning the fight for liberty in exchange for a British bribe. Reed's defiant reply became a legend: "'I am not worth purchasing; but such as I am, the King of Great Britain is not rich enough to do it.'"[40] Word spread of Ferguson's involvement and on July 26, 1778, she received an issue of *Towne's Evening Post*—seen behind her on the floor—containing an article critiquing her actions. Henry depicted her at her suburban Philadelphia estate, Graeme Park, at the moment when she seals a letter to Reed rebuking him for allowing her to be portrayed in the papers as a British pawn.

It was not only her subject, but also Ellet's methodology that inspired Henry. One of the first historians, she imposed an objective standard by insisting on "authenticity";[41] however, she also imparted a sentimental tone through descriptions of each heroine's charms rather than a litany of names and dates.[42] Henry's painting demonstrates the same delicate balance of fact and drama. Yet finding that equilibrium was not easy—critics and audiences would both reject excessive detail as busy and superficial, and its lack as inauthentic, and thus an obstacle to reconstructing a national identity rooted in the past.[43] *Drafting the Letter* represented a particular challenge, as Henry acknowledged to Etting: "The idea was a rather difficult problem in art to solve and the picture might prove a failure but happily the long watchfulness over its birth has had its reward."[44] His description reflects the challenge of bringing a textual source to life. He combed Ellet's biography of Ferguson, choosing to depict her rebuttal to Reed's charge, a vignette discussed but not illustrated in the plates in Ellet's book. To image the event, he combined authentic documents, such as Ferguson's letter of reproach—reprinted by Ellet—with

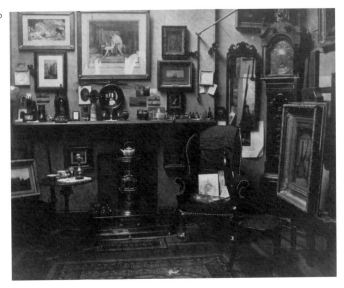

FIG. 9 (opposite)
Drafting the Letter, 1871
Oil on board, 10 ⅛ x 12 ⅝ in. (25.7 x 32 cm)
Collection of Mr. and Mrs. Frank L. Hohmann III

FIG. 10
Unidentified photographer
Henry's atelier in the Tenth Street Studio Building,
New York, 1867–68
Albumen print, 8 ½ x 10 ¾ in. (12.7 x 27.3 cm)
New York State Museum, Albany
(not in exhibition)

an imaginative assemblage of studio props, re-creating the past by giving it a visual form constructed in the present.[45]

To provide a documentary foundation for his historical fiction, Henry traveled to Graeme Park. In June 1871, he wrote to Etting that he was on the verge of completing *Drafting the Letter,* a painting set in "the Room I made a Drawing of last summer."[46] An earlier letter and the artist's sketchbooks suggest that he made an extensive collection of such drawings for composing paintings in his studio. "My stock in trade is that of an antiquary," he had declared, "[I] have Illustrated nearly all the old Houses & Churches in Phila, New York, Newport & other places where there is anything worth looking up."[47] A newspaper reported that, "in its architectural aspects [*Drafting the Letter*] is historically correct, as the artist made his drawings on the spot from nature."[48]

Despite his reliance upon direct observation, the degree to which the painting was considered "historically correct" reveals much about Henry's methods and his audience's assumptions about what constituted accuracy about the past. He replicated the fireplace tiles and each dentil in the cornice, presumably relying on his sketches, which are no longer extant. But it is unclear whether Henry verified his impressions against representations of Graeme Park in the Revolutionary War era in which his scene is laid.[49] Graeme Park's eighteenth-century accoutrements had been dispersed over time, and the artist furnished the room using sketches of chairs, mirrors, and case pieces from his own collection. Although passionate about antiques—and indebted by expenditures on rare objects—Henry combined furniture from various times and places in his paintings, rather than insisting only upon items that Ferguson, for example, owned or could have possessed—the standard to which we would hold a period interior today.[50] He owned a mirror and wing chair nearly identical to those in *Drafting the Letter* but took small liberties with the latter, giving it patterned upholstery (fig. 10).[51]

Henry's audience accepted his selections and modifications under the flexible mantle of the "antique." The accuracy of his choices was irrelevant to colonial revival audiences as long as the furnishings enhanced the depicted event's perceived authenticity, providing a tangible link to history.[52] Whether or not it had ever been at Graeme Park, the high chest's carving, painted with a craftsman's appreciation for each ridge and swirl, made the past more vivid, a comfort in tumultuous times. In fact, the profusion of such details served a crucial narrative function, encouraging viewers to elaborate upon the story—to make it their own by adding, as one journalist did, that the painting included Ferguson's "favorite cat."[53] After the profound transformations engineered by war, the wealth of detail affirmed the past's enduring reality for those who embraced it as a reassuring counterpoint to current ills; at the same time, the elastic temporal standard exhibited in historical fictions like *Drafting the Letter* allowed the past to remain a touchstone for the present, by virtue of its adaptability to contemporary cultural demands.

Like the searing candle flame in which Ferguson melts her wax, slavery's legacy remained too volatile to address directly in 1871. Henry's invention of the African-American messenger, not mentioned in Ellet's narrative, underscores the extent to which history provided a medium for tackling divisive issues. Before the Revolution, the vast majority of African Americans in Pennsylvania were slaves.[54] Henry acknowledges African Americans as a part of "Revolutionary Memory," but in the role of servants, with the implication that history dictated they continue to occupy this subservient rank.[55] Apprehensive about emancipation's consequences for the urban North, his audience embraced a portrayal of their past that preserved antebellum norms.

By couching the debates of his day in early American history, Henry fabricated a justification for contemporary social and racial hierarchies.

Increasingly, wealthy Americans responded to lingering racial tensions, rising immigration, and class conflict by promoting history as a unifying force that could provide a template for the present, a concept first developed in the effort to restore a sense of national identity during Reconstruction. Institutions like the National Museum, organized in 1873 at Independence Hall by Henry's friend Etting, provided a "means of reviving the memories of 1776, and thus again cementing the Union then formed."[56] As America's centenary approached, history was openly deployed to counter social unrest. One newspaper report of Philadelphia strikers' "revolutionary schemes to procure employment" was followed by an account of the Centennial Tea Party, "a national one in every respect," organized to raise funds for the city's 1876 exposition.[57] The tea party and Centennial Exhibition celebrated the fiction of a common past that was meant to unite people otherwise divided along ethnic and economic lines.

Elite Philadelphians like Samuel Chew III and others of his class quickly gleaned the importance of shaping public understanding of the past as a means of asserting a social hierarchy in the present in which they occupied the top position. Encouraged by Etting, he and his wife Mary began promoting their family's ties to American history, appointing themselves its custodians to ensure their relevance in light of eroding economic and cultural dominance. Mary Chew orchestrated displays of colonial artifacts at the National Museum and at the Centennial Exhibition that presented her ancestors' possessions as embodiments of the American past, while her husband Samuel publicized the Chews' centrality to the nation's history through the medium of their suburban Philadelphia estate, Cliveden.[58]

Built in the 1760s by Pennsylvania's Chief Justice Benjamin Chew, Sr., the house was associated with two important events, the 1777 Battle of Germantown and a reception held in honor of the Revolutionary War hero Marquis de Lafayette during his triumphal 1825 tour of America. Samuel Chew restored the ancestral home, collecting and displaying family artifacts on site and at the National Museum.[59] By the late 1860s, he regularly distributed photographs of the house to increase awareness of the Chew family's role in American history.[60]

To reach a wider audience, he commissioned Henry, to whom he had been introduced by Etting, to paint *The Lafayette Reception* (fig. 11). The richly colored interior scene of guests introducing themselves to the French statesman did what photographs of the house's exterior could not: re-create the long-ago occasion upon which the Chews based their claims of cultural authority.[61] As no visual record of Lafayette's visit survived, Henry's efforts to visualize the scene offer a glimpse into the phenomenon of colonial revival historical re-creations. It was crucial to Chew that the painting render the reception as authentically as possible. He wrote to his aunt, Anne Sophia Penn Chew, who had been present on July 20, 1825:

> I have ordered a painting of LaFayette's reception at the Battle Ground and I beg you to write me a description of where he stood, where other people stood, who introduced them, where people gathered, where you stood, who were present, how dressed & etc. Do not fail me dear Aunt or my picture will be only an imaginative picture, and that I don't want.[62]

To collect accounts of the reception, Chew urged the editor of Germantown's newspaper to publish an appeal for information from residents who remembered the day or could provide likenesses of those known to have attended. Chew supplied Henry with these documents along with a photograph of the entry hall where the reception took place.[63]

FIG. 11

11

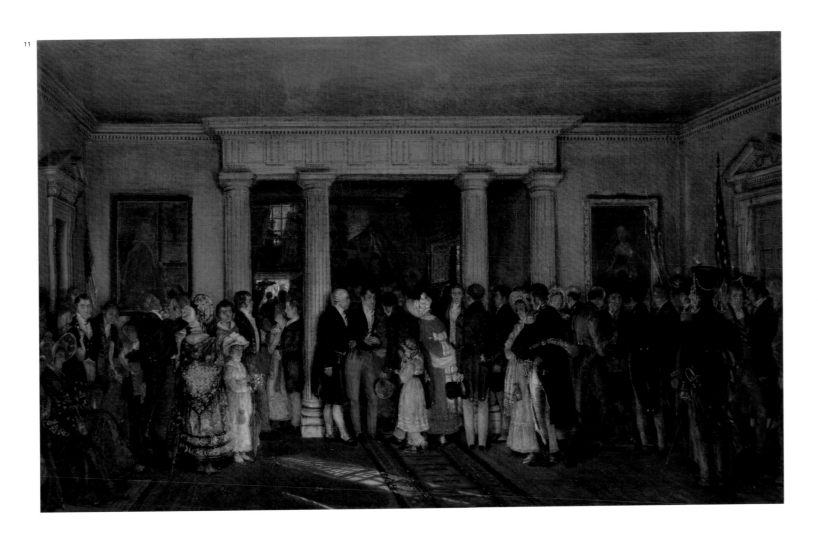

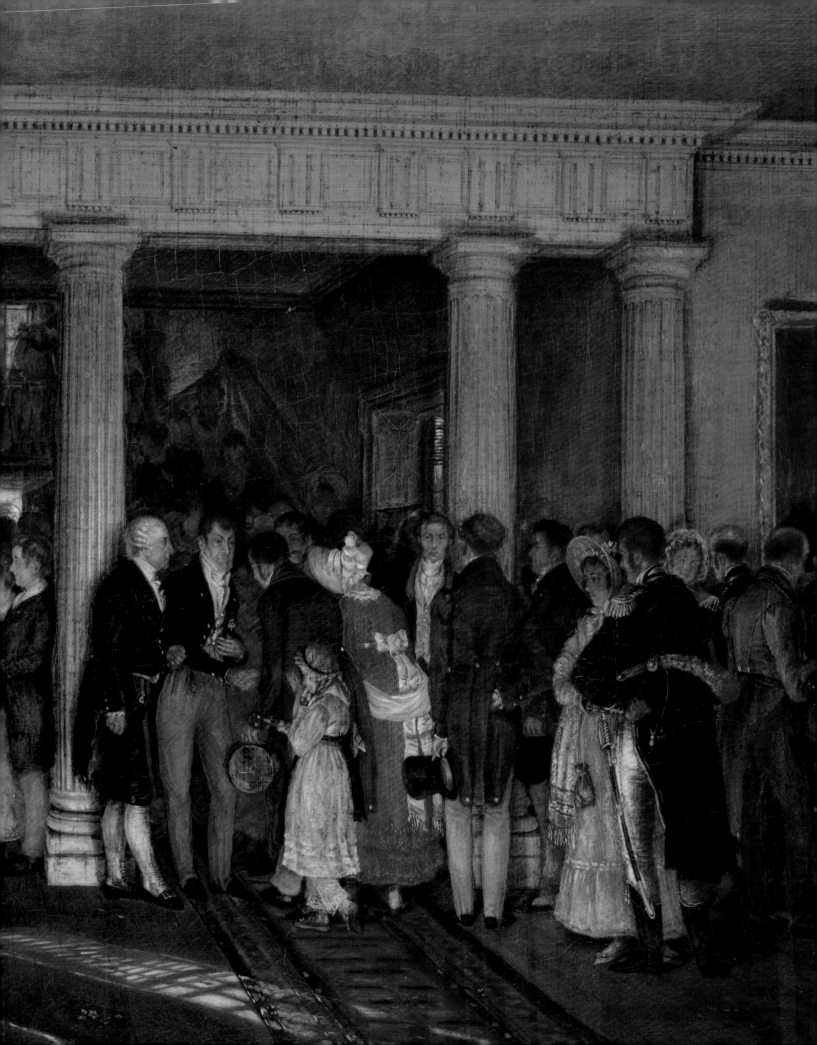

(opposite)
Detail of *The Lafayette Reception* (see fig. 11)

FIG. 12
Female figure study for *The Lafayette Reception*, on the back of a photograph of Cliveden, 1873–74
Graphite on paper, 8 ¾ x 6 ¼ in. (22.2 x 15.9 cm)
New York State Museum, Albany

FIG. 13
Male figure study for *The Lafayette Reception*, 1873–74
Oil and graphite on paper, 11 ¼ x 8 ½ in. (28.6 x 21.6 cm)
New York State Museum, Albany

FIG. 14
Figure studies for *The Lafayette Reception*, verso of *Waiting for the Stage*, 1873–74
Oil and graphite on paper, 10 x 11 ½ in. (25.4 x 29.2 cm)
New York State Museum, Albany
(not in exhibition)

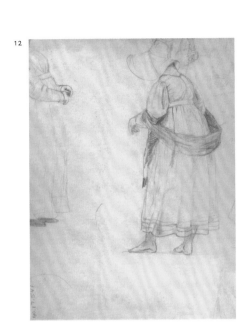

Drawing upon these materials and visits to Cliveden, Henry infused the painting with details of the Chews' moment of glory. Host Benjamin Chew, Jr., occupies a central place left of Lafayette. Visitors fill the vestibule, spilling up the stairs like those who, according to firsthand accounts, had returned several times to shake the marquis's hand. Soldiers who had escorted Lafayette to Cliveden pause near an aproned member of one of the Masonic Lodges, to which the marquis was presented in Germantown.[64] Lest viewers forget Cliveden's other significant chapter, a man on the left directs a group's attention toward bullet holes in the plaster above the painting on the right dating from the battle of Germantown. His sweeping gesture underscores the Chews' prestigious roots in America's past.

While Henry employed photographs of likenesses of some attendees, the dearth of life portraits of Chew's grandfather Benjamin potentially undermined the painting's ultimate purpose.[65] Verbal descriptions capture the gentleman's penchant for powdered wigs and knee breeches, considered old-fashioned by 1825. But, forced to invent a likeness, Henry warned his patron, "You must not forget however, that some of the principal faces in this picture were painted from black silhouettes and the filling in of the faces and the color was left entirely to the imagination, so deal as lenient [sic] as possible under the circumstances."[66]

Although it was in part the "imaginative picture" Chew feared, *The Lafayette Reception*'s wealth of documentary detail and the prominence given to his ancestors pleased him enormously—perhaps because as an historical fiction, its hybrid nature so suited his intended uses. When a relative mistook the painting for an eyewitness rendition of the event, Chew's gratitude was immeasurable.[67] His enthusiasm exhibits an acceptance of certain liberties, despite assertions to the contrary, when the resulting historical fiction offered a vision of events amenable to upper-class patrons who increasingly strove to shape narratives about the past.

To re-create convincingly the sights of 1825, Henry conceived of the composition as a tableau vivant—a popular form of entertainment in which people acted out scenes from history or literature—relying upon artists' models costumed in the styles of the 1820s.[68] Working on the back of a photograph of the Chew mansion, he contemplated the central female figure from the back and side, repeating and cropping it to study her old garments and discern her proper position in the final composition (fig. 12). "I have dresses or at least can obtain them of the period," he explained to Chew (see opposite p. 1). "I only need an old coat of the time swallowtail or Frock it is all the same for I wish merely to get the effect of the narrow high collar sloping effect which I cannot do from a Modern one."[69] He punctuated his description with a sketch of a man wearing the desired type of jacket, in the hope that Chew could help him procure one. Henry believed a period coat's authenticity would be transposed onto its wearer, contributing to the painting's veracity by enabling the artist to project his imagination back into the 1820s. He delineated in graphite the body of the man introducing himself to Lafayette, experimented with his shoulder and coat tail, then "dressed" his creation in oil pigments (fig. 13). In this and several smaller oil and pencil studies, Henry tested movement's effect on the swallowtail coat as the bodies reach and twist (fig. 14).[70] The more polished study of the isolated man so convincingly articulates his pose that the viewer expects to see Lafayette clasp his extended hand; utterly convincing under the painter's deft, directorial touch, the figure summons a vanished moment.

A dream Henry recounted to Chew reflects the artist's belief in the ability of old clothes and antiques to conjure an earlier world:

FIG. 15
Waiting for the Stage, 1872
Oil on paper, 11 ½ x 10 in. (29.2 x 25.4 cm)
New York State Museum, Albany

I dreamed the other evening of ransacking through your old garret with you amongst old chests, in old presses, and like all dreams the imagination ran riot and I was bewildered with the most rare old costumes, old china, silver, quaint, singular specimens of Furniture, till they seemed endless, and my wonder why you never spoke of it, as having such treasures up there before, and such a disappointment to find it a Dream. Perhaps though, there may be a reality and I was for a time clairvoyant.[71]

15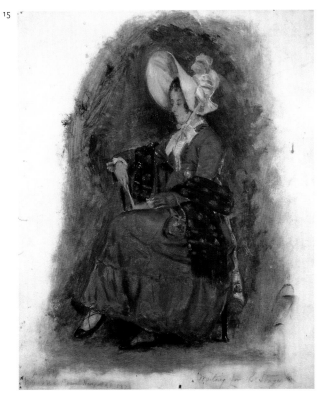

Henry's reverie transported him to a world in which history swirled around him in a parade of material goods that created their own intoxicating reality. As his wife later recalled, "an old chair, an old clock, an old piece of china, was full of memories of those who had used and handled them."[72] He nourished the intense yearning for the past expressed in his dream, and prolonged its sway, by collecting and donning historic clothes.[73] In Newport, where he vacationed, and Cragsmoor, the art colony he later founded in upstate New York, Henry acted as the impresario of historical pageants, encouraging friends to delve into his sartorial treasures. An oil sketch, inscribed "Posed by Miss M. E. Powel, Newport, R.I., 1872," commemorates such an occasion (fig. 15).[74] Two years later, Henry inserted this seated figure, reversed, into the left side of *The Lafayette Reception* and made additional costume studies for the painting on the back (fig. 14). Thus, the record of his upper-class friends' leisure-time sessions of historical "dress-up," originally opportunities to retreat to a world whose difference from their own they idealized, became the building blocks of images like *The Lafayette Reception* that enshrined their fantasy as American history.

In addition to encouraging his friends to pursue the joys of historical re-creations, Henry photographed himself in eighteenth- and early-nineteenth-century garb. A tintype of him in a tailcoat, seated on a chair with his legs crossed

(fig. 16), served as a study for *Spinning Jenny* (fig. 17), a painting of a man watching a woman operate an archaic vertical yarn spinner.[75] With only minor alterations, Henry transposed himself from one scene to the other, accomplishing on canvas the ideal of reexperiencing early American life. Reflecting upon her husband's desire to reinhabit the past, Mrs. Henry observed, "he lived in his painting."[76]

Lost in thought, the artist's painted analogue gazes at the machine's whirling metal wheel, whose spokes dematerialize into a blur. Located at the canvas's center, the wheel emanates a mesmerizing energy that unifies

FIG. 16
Unidentified photographer
Edward Lamson Henry seated, wearing
old costume, study for *Spinning Jenny*, ca. 1874
Tintype, 7 x 5 in. (17.8 x 12.7 cm)
New York State Museum, Albany

FIG. 17
Spinning Jenny, ca. 1874
Oil on canvas, 11 ¼ x 12 ¼ in. (28.6 x 31.1 cm)
New York State Museum, Albany

17

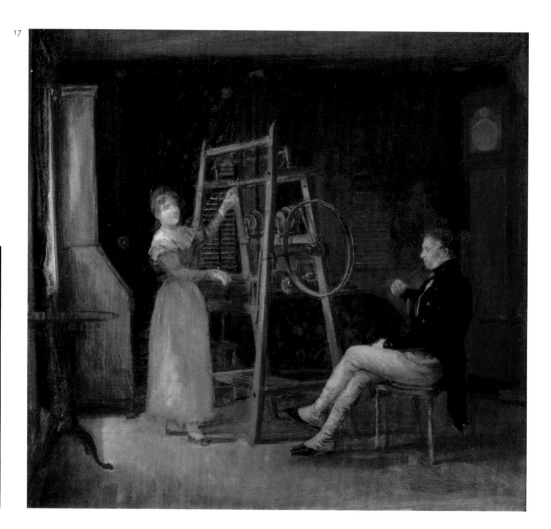

16

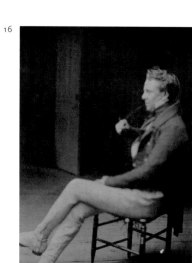

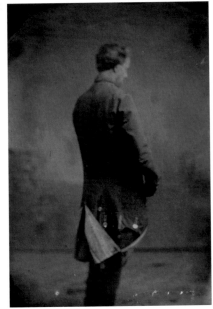

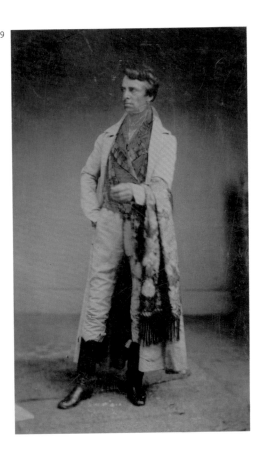

the composition by radiating the upside-down V of the red struts, a shape echoed in the sloping edges of the drapes. Lines implied by Henry's extended legs and the woman's similarly colored, advancing foot and arm intersect the inverted Vs, encircling the wheel and channeling its energies back into the machine. Powered by the female model and fed by the raw material of the man's rapt attention, the twirling wheel visually generates *Spinning Jenny*—a pictorial yarn in which the analogy between mind and machine can be interpreted as an allegory of the creative process. Beginning with the costume photograph, Henry ginned the historical vision on view in the painting solely from his imagination, distributed by the churning wheel, but contained by the hermetic box of deftly placed diagonals. It is telling that Henry, who was often concerned about his finances, never finished the painting and kept it until his death, perhaps as a reminder of his ability to conjure and inhabit the past at will.[77]

Retaining the incomplete *Spinning Jenny* suggests that the artist was at times ambivalent about history's potential to loosen one's attachments to the present and transport one to another realm. A tintype of Henry wearing a military coat and sword depicts him with his back to the camera (fig. 18). With Henry lost in thought, his features ghostlike, the coat is the lonely sentinel's most tangible property.

Although in one sense a study of the old mantle, the photograph is also a self-portrait the artist created for private use. Alienated from the present, he turned to the past to reconstruct a sense of reality, but his dissolving visage suggests the psychological perils of this remedy. The bewilderment first referenced in Henry's dream—the disorientation produced by history's "endless" relics—resurfaces in this costume portrait as the potential flip side of the fondness for projecting oneself into the past. As he wrote of his intense engagement with one such historical picture, "I was so intent on working to completion the painting I am engaged on . . .that I might say I was lost to every other subject outside."[78] A handcolored tintype of Henry wearing an old coachman's overcoat and plaid vest projects a confidence lacking in the military photograph (fig. 19). Billowing around his calves, the mantle imparts swagger to his five-foot-six frame. But robing himself in antique garments to assume his subjects' personae, re-creating the past through the vehicle of his own body, only exposed the fragmented state of late-nineteenth-century selfhood. Nevertheless, inhabiting his own historical fictions allowed Henry to lay claim, albeit provisionally, to the identities vested in each set of old garments, trying each one in the struggle to resolve his place in a changing world.[79]

History and Social Definition

Henry's historical fictions frequently took the form of re-creations of earlier moments; however, his portrayals of contemporary life also powerfully reflect the extent to which Americans turned to the past to define themselves in the present. Wealthy New Yorkers invoked the allure of art and antiques to assert social and economic supremacy, positing a taste for old china and furniture as the criteria for cultural authority. Stewarding this historical legacy became a crucial means of addressing immigration, urban stratification, and class conflict. Henry's cityscapes articulated these divisions and encouraged a respect for physical and social place as the antidote. At the same time, his rural scenes entrenched myths about America, selecting aspects of life from the recent past as the basis for a common identity in an increasingly diverse society.

Parlor on Brooklyn Heights of Mr. and Mrs. John Bullard testifies to the central role of art and antiques in the upper classes' self-definition (fig. 20). In the scene, "Painted from Nature for them," the wealthy leather and hide merchant and his wife sit in their parlor at 220 Columbia Heights.[80] Furnished in an eclectic variety of styles that teams an Elizabethan fire screen with Renaissance revival woodwork, the room itself is a temple to the past, albeit one in keeping with tastes of the early 1870s. Although likely contemporary pieces, a statue of Venus on the right, one of Athena above the mantle clock, a nude male figure by the window, and the large bust of Medusa by American sculptress Harriet Hosmer exemplify an appreciation for classical Greek and Roman culture, as do the polychrome urn and amphora mantle garnitures.[81] A frieze-like painting on the right depicting figures on a gold ground and the three most ornately framed images on the left represent the art of the Middle Ages and early Renaissance. As collectors of Old World relics, Mr. and Mrs. Bullard not only exhibit their wealth but lay claim to the full span of Western European culture since ancient times—presenting it in miniature in their parlor, appointing themselves its guardians, and declaring their sophistication through its display.

In an era in which merchant financiers like Bullard felt themselves overshadowed by emerging industrial tycoons and losing ground to the lower classes, culture became a crucial means of retaining an unassailable foothold in the social hierarchy and formulating a stable class identity.[82] These elites helped build institutions like the Metropolitan Museum of Art, founded in 1870, as a means through which to define culture for the masses, facilitate social harmony, and bond with compatriots who had named themselves its custodians.[83] Declaring their affinity with this group, the Bullards exhibited their paintings— including Henry's antiquity-infused portrait—publicly, and played an active role in such institutions as the Brooklyn Art Association, Brooklyn Philharmonic Society, and Brooklyn Academy of Music, designed to encourage "refined and cultivated tastes."[84] Much like historical preservation societies, cultural institutions became the bastion of the economic elite, who carefully crafted their collections and programs into didactic tools intended to inculcate in the lower classes a respect for tradition and its keepers.

While the Bullards' portrait attests to their command of high culture from across the ages, it also proclaims their

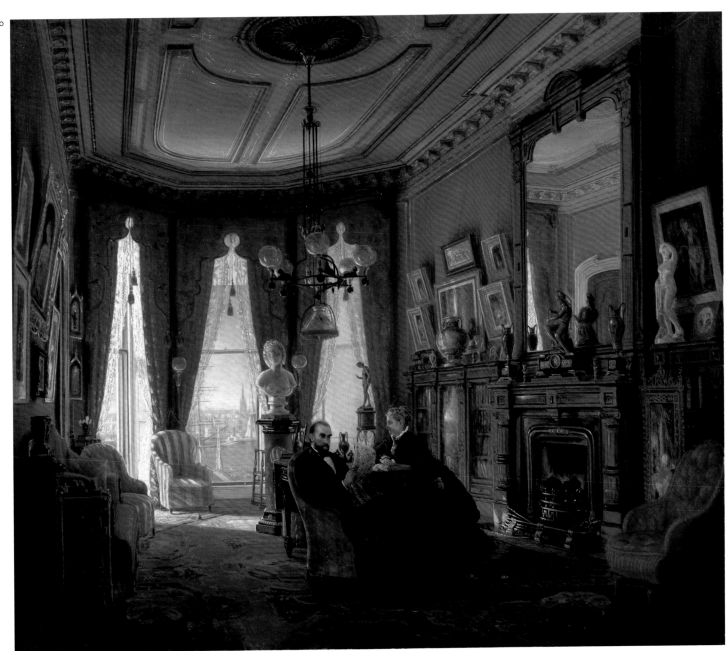

FIG. 20
Parlor on Brooklyn Heights of Mr. and Mrs. John Bullard, 1872
Oil on panel, 15 3/8 x 17 5/8 in. (39.1 x 44.8 cm)
Manoogian Collection

20

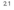

FIG. 21
A Lover of Old China, 1889
Oil on academy board, 14 x 12 in. (35.6 x 30.5 cm)
Collections of Shelburne Museum,
Shelburne, Vermont

deep ties to American history.[85] The antique slatback rocking chair between Hosmer's *Medusa* and the window is an allusion to John Bullard's New England ancestors, who settled in Dedham, Massachusetts, in 1635.[86] Although probably an eighteenth-century piece, flexible notions of "the colonial" permitted the chair to be seen as a relic of Puritan forebears. In the years surrounding the Centennial, families with long-standing ties to America's past, like the Bullards and Chews, promoted their descent from the vaunted Puritans by displaying tangible remnants of the colonial period in exhibitions like those held in Philadelphia in 1876, and in their homes. They argued that such objects embodied moral lessons for contemporary Americans, particularly those of lower economic status or foreign birth otherwise unfamiliar with Anglo-Saxon values. From his mansion on the Heights overlooking

Brooklyn's teeming, seedy waterfront tenements and warehouses, Bullard likely felt all too aware of the pressing need for social consolidation.[87] With its spare, unadorned form, so different from the furniture around it, the rocker is an emblem of modesty and restraint. Bullard promulgated this social philosophy through membership in the New England Society and Brooklyn's Church of the Pilgrims, both of which promoted the Puritan ethic of hard work and piety through personal example and outreach to those less fortunate.[88] His charitable donations of $25,000 upon his death ensured the ongoing propagation of these values.[89]

As Henry's *A Lover of Old China* attests, the taste for antiques became a crucial means of distinguishing and defining oneself (fig. 21). The painting depicts an elderly woman removing one piece of tableware from a corner cabinet while her male companion examines a teacup's mark.

FIG. 22
Studies of blue-and-white china, ca. 1870
Watercolor and graphite on paper, 5 x 3 ½ in.
(12.7 x 8.9 cm)
New York State Museum, Albany
(not in exhibition)

Antiques, including china, were first collected in the mid-nineteenth century, largely for their associations with historical figures and events.[90] By the 1870s, machine-made goods inspired a backlash among reformers who issued calls for greater simplicity and a renewed appreciation for handicraft. Although their attitudes encouraged the artisanal production of new goods, they also fostered an intense interest in antiques as aesthetic and not just historical specimens. Turning their backs on the industrialized economy they blamed for social destabilization and urban unrest, elites devoted themselves to collecting and preserving unique, rare, and beautiful handmade objects.

In a world in which money alone no longer guaranteed an older mercantile class's relevance against the advances of newer manufacturing wealth, taste emerged as a criterion for asserting social authority distinct from purchasing power. Just as the Bullards' early American rocker was intended to corroborate their genealogical predisposition toward good taste, carefully selected old china and furniture were believed to declare their owners' discernment. In *A Lover of Old China*, the gentleman exhibits this class-specific insight, exclaiming "Why this is Spode!," as one version of the image was captioned when it was published as an illustration for Clarence Cook's 1878 discourse on the gospel of tasteful simplicity, *The House Beautiful*.[91]

Like his audience, Henry defined himself through his collecting, parlaying his passion into a lucrative sideline that was as much his "stock-in-trade" as painting. He purchased antiques on commission in Europe for his Philadelphia patron Joseph W. Drexel and acted as an adviser and agent for the sale of historic tapestries.[92] His own love of rare china is evident in a watercolor sketch of blue-and-white ware (fig. 22), examples of which he included in both historical and contemporary scenes (figs. 9 and 30). To publicize his artistic tastes, Henry even exhibited his selections in displays of decorative arts.[93] Forced to close his New York studio when he moved to

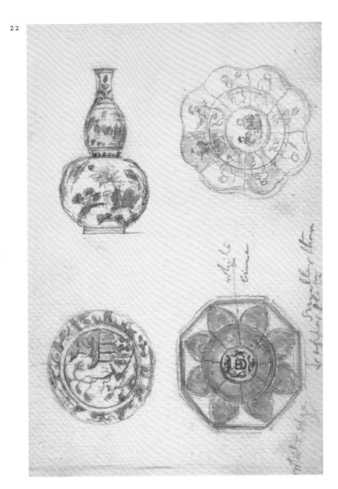

22

Cragsmoor in 1887, he reluctantly auctioned much of his collection, fondly describing in the catalogue the history, origin, and aesthetic merits of pieces gathered over the course of two decades.[94]

The artist and his fellow collectors shared the fantasy of a world insulated from reminders of their industrial age, which had begun to feel alien. A self-described "rabid native American," Henry lamented "the enormous sewage of Europe now here" and decried "the encroachments of

the low orders and their offspring here in New York."[95] *A Philadelphia Doorway*, one of his few contemporary urban scenes, conveys some of the tensions present in late-nineteenth-century American cities (fig. 23). Eyeing the dog poised in the doorway, a delivery boy bearing a basket of produce pushes open the townhouse's full-length, grilled gate. The dog's perked ears and the lapping of his paw over the threshold suggest his alertness to the impending intrusion. The clash of worlds was one that city dwellers like Henry came to see as the result of social forces that brought ethnically and economically diverse groups into close proximity in ever larger metropolises. The compositional emphasis on walls, doors, gates, and fences, which Henry organized into a series of nested rectangles, divides and orders the space much the way affluent city dwellers—like the Bullards in their Heights aerie—partitioned their world to regulate the interaction of social classes. Brick walls and iron bars created a buffer zone around houses, privatizing outdoor space for individual use. Even parks—like the one hinted at by the distant trees—originally created as oases free of urban grime and tumult, were sealed off and their hours limited to restrict their appropriation by the poorer classes.

Street lights, like the one in *A Philadelphia Doorway* that arches so prominently directly over the watchdog's head, constituted another gesture toward regulating the urban environment. Lamps were installed in cities to address the perceived dangers of the night, a dark period in which crime and immorality resurfaced to threaten the social order.[96] Distributed first in commercial and well-to-do residential neighborhoods, the lights claimed those streets for the wealthier classes, easing their navigation of the city, while poorer folk muddled along dark sidewalks. Because lighting was so closely tied to social distinctions mapped onto urban space, blackouts or failures in outdoor illumination due to strikes unleashed the specter of chaos as class differentiations disappeared in the gloom of unlit streets.

Set in the daylight, *A Philadelphia Doorway*'s prominent lantern serves as a reminder of the first line of defense against the "wildest excesses of mob rule," like that which prevailed during New York's July 1871 "Orange Riots." The protestors, one newspaper wrote, "only come forth in darkness and in times of disturbance, to plunder and prey upon the good things that surround them."[97] Henry further underscored the sense of threat through his attention to the delivery boy's deep shadow, the first part of him to breach the gate, and the double locks visible on the left side of the townhouse door.

Encouraging immigrants and the poor to abandon their native identities in favor of American ones increasingly seemed, to troubled elites, the only solution to the crisis of social cohesion. Because of its public nature, historic architecture, like that introduced in *The John Hancock House* and depicted in *A Philadelphia Doorway*, promised to teach a divided people American values by nurturing a sense of place. Even anonymous structures, like the federal-era building framing *A Philadelphia Doorway*'s cityscape, could serve this purpose by virtue of their long-standing presence on urban streets. Thus images of them were circulated as tools for the Americanization of immigrants.[98] The streetlight Henry depicts in *A Philadelphia Doorway* as part of the urban architecture is another such symbol of place; its design derives from one patented by Benjamin Franklin, whose improvements to such lamps enabled their widespread, early use in Philadelphia, of which they had become symbols. Incorporating references to the city's past and to Franklin, a national icon, made even modest scenes like this treatises on American history and values.

With mounting urbanization, the nationalistic sense of place was most strongly vested in rural areas, territory still deeply associated with the agrarian ideal first advanced by Thomas Jefferson as the core American identity. Henry turned to country scenes, particularly after his move to the Cragsmoor art colony in upstate New York in the 1880s, in

FIG. 23
A Philadelphia Doorway, 1882
Oil on panel, 10 x 8 in. (25.4 x 20.3 cm)
Yale University Art Gallery, Partial and promised
gift of Mr. and Mrs. Andrew J. Goodman, B.S. 1968
TR2003.12925.2

23

FIG. 24
A Country School, 1890
Oil on canvas mounted on composition board, 12 x 17 ¼ in.
(30.5 x 43.8 cm)
Yale University Art Gallery, Mabel Brady Garvan Collection
1948.98

24

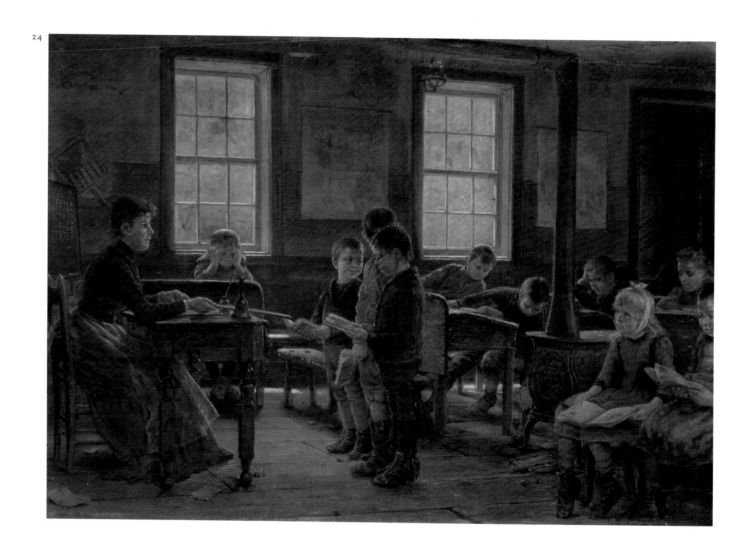

search of subject matter that would speak to the perceived need for a unified conception of who Americans were. Since the early 1870s, when Winslow Homer created his iconic *Country School*, depictions of rural education had offered a compelling option for "thoroughly national" pictures.[99] Rustic, one-room academies, with their free instruction, were traditionally believed to instill both literacy and civic awareness, theoretically preparing students to participate in a democratic society. Moreover, few tales of Gilded Age tycoons' success were complete without glowing references to their boyhood tutelage in rural schools, where they absorbed the rudiments of greatness.[100]

Henry's 1890 *A Country School* draws upon this heritage, depicting three boys—citizens in training—reciting before the class (fig. 24). But by that year few such schools were left, the casualty of waning rural populations and changes in educational philosophies. Henry's rendition—despite the inclusion of a female teacher and instructional aids like maps, both of which only became common in the 1870s—is more of a nostalgic myth than a contemporary reality.[101] But for urbanites with rural childhoods, free, universal education remained a powerful ideal. In it, they saw the promise of a better life for their children and the means of creating a homogenous American identity that would encourage social stability. *A Country School*'s positive reception—it was deemed "the best picture [Henry] has shown for a long while"—conveys the depth of enthusiasm for this vision.[102] In fact, economic necessity forced many children into factories, and those who received an education frequently did so in their native languages, not English, undermining schools as a nationalizing force. In 1889 and 1890, several states passed compulsory education bills that mandated attendance and instruction in English in an attempt to conform reality to the ideal depicted in *A Country School*.[103]

For all its nostalgic veneration of rural instruction as the foundation of American civic life, *A Country School* hints at the potential pitfalls of democracy. One boy has spilled his ink on the floor—a longstanding metaphor for the exercise of free speech—distracting several children, including two called upon to recite. Poised to speak, the teacher levels her ruler—a potential instrument of corporal punishment—toward the boys in an effort to restore focus before she loses control of the class. The ease with which order degenerates corresponds with Gilded Age elites' fears about American democracy, in which the populist masses and the political machines serving them were envisioned as a perpetual threat to the establishment. The "judgment of the majority," one newspaper declared, "cannot be relied upon to afford a safe and efficient administration of public affairs."[104] Although manipulated for humorous effect, the girl on the right's bandaged head posits one possible remedy— by restricting her ability to open her mouth, it acts as a gag, silencing her. Despite his efforts to compose a reassuring view of an American institution for posterity, Henry's loosely historical portrayal of rural education conveys both the dreams and divisions that marked late-nineteenth-century society and politics.

Uncertainty in the Age of Rail

"How is it possible to attain any sense of the past
when the present is thus omnivorous?"[105]

Henry T. Tuckerman

Of all the changes that transformed Americans' lives over the course of the nineteenth century, none were more dramatic than those wrought by the railroad. In the six decades after their introduction in the 1830s, trains revolutionized American life, facilitating the movement of people and goods to cities, permitting rapid travel and trade, and knitting the country together to a degree previously unimaginable. Quickly becoming one of the nation's largest industries, railroads catalyzed manufacturing, urbanization, and the emergence of the modern corporation, and provided the livelihood of hundreds of thousands of Americans. Surging along tracks extending diagonally to a Western horizon, trains became icons of progress— one-way tickets to the future that turned their backs on the past (fig. 25). The railroad was so thoroughly associated with the present that "All the information upon the subject" of its origins, despite transpiring "within the lifetime of millions in our community," one author wrote, "seems to be wrapped in impenetrable mystery."[106]

By the 1890s, though, Americans increasingly struggled to make sense of a force that so shaped their lives. The relentless forward drive associated with railroads produced a sense of dislocation captured by Henry T. Tuckerman,

who asked, "What room is there for retrospection when steam and electricity thus concentrate the significance of every passing hour?"[107] The same yearning to look back and take stock is evident in Henry's undated watercolor sketch made from the rear window of a train's observation car (fig. 26).[108] The tracks curve out of sight, hiding the past from view as the train pushes forward. If technology thwarted attempts to look back, Henry would make the railroad itself the vehicle for retrospection.

The impetus toward reflection peaked in 1893 around the World's Columbian Exposition, which celebrated the four hundredth anniversary of Christopher Columbus's arrival in the New World. Held in Chicago, a metropolis built by the railroads, the exposition presented the apex of modern achievements in art and manufacturing. Locomotives and luxury passenger cars from every nation, housed in the Transportation Building, embodied the century of invention.[109] Amid these technological wonders, Henry presented his monumental *The First Railroad Train on the Mohawk and Hudson Road* to illuminate the historical roots of the railroad's contemporary dominance (fig. 27). The sweepingly horizontal painting depicts the initial trip of the engine DeWitt Clinton between Albany and Schenectady, New York, in 1831—one of the first passenger train journeys in the United States.[110] The work likely formed part of the historical collection assembled by the Baltimore and Ohio, New York Central, and Hudson River Railroads, which also included a replica of the DeWitt Clinton.[111]

Henry selected the moment of departure for his canvas: a man stokes the fire to produce the requisite first burst of steam, while the railroad's benefactors await in the stagecoaches that served as passenger cars. With the train about to start, it is the zero hour at the dawn of an era. Under the guise of celebrating its inception, Henry returns us to the instant just before the age of American rail, enabling him to suggest an alternative history for this disruptive technology.

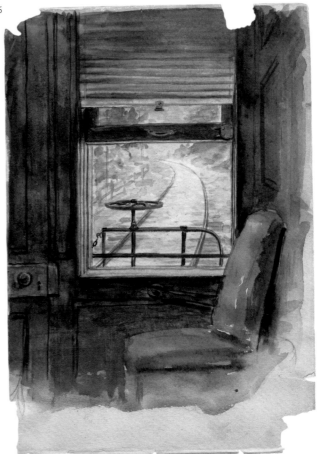

In contrast to *Across the Continent*, the engine does not race into the distance—and by implication the future—but rather idles on a nearly horizontal line, almost parallel to the horizon. The more static format disassociates railroads from the spatial suggestion of progress. Henry further stilled any sense of advancement by positioning the track bed, the intersecting road, the phalanx of people just left of center, and the lumber and metal bars in the foreground so that they converge in the composition's middle rather than on the train's engine. There is no forward momentum, only an expansive sense of the moment that is the antithesis of the concentration of experience Tuckerman lamented as technology's byproduct.

Despite its inclusion in an exhibition intended as an encomium to technology's contributions to American life, *The First Railroad Train*'s historical *mise en scène* and compositional avoidance of progress hint at lingering anxieties about railroads never far from the surface in 1892–93. As early as 1877, railroads' mistreatment of workers resulted in the first national strikes, during which government militias crushed protests. The bloody Homestead Steel and Pullman Car Company walkouts of 1892 and 1894 bracketed Henry's work on *The First Railroad Train* and its display in Chicago. Moreover, as the artist strove to complete the painting in preparation for the Columbian Exposition, the March 1893 collapse of the Philadelphia and Reading Railroads set off shock waves in the stock market, bankrupting the major rail lines and sending the country reeling into a depression.

Henry's verbal description of the DeWitt Clinton's first trip conveys a fundamental uneasiness about railroads that is couched in historical trappings but nevertheless expresses the public's concerns about the industry in the 1890s. He wrote of the brakeless cars' jarring tendency to "jerk" when started or stopped, labeling it "a source of terror to the passengers," and closed with a paragraph describing the perpetual danger of sparks burning riders. Though a technology enthusiast, Henry pronounced his painted sitters "as ignorant as their horses as to what a railway train really was when it came rushing on with noise of the wheels, breathing smoke and fire." Although rail travel opened new vistas of employment and settlement, Henry concluded that "the sequel was runaways, smashups and a large number of bad accidents."[112]

Yet by focusing on the past, Henry enabled himself to reimagine the railroad as a marvel of human achievement rather than a destroyer of dreams, and the cluster of onlookers as excited witnesses to a pioneering feat rather than embattled workers blocking a train's passage—a more familiar image at that time. Audiences at the Columbian Exposition, Corcoran Gallery, and Metropolitan Museum of Art shared in this fantasy, standing three deep for a glimpse at the canvas, photogravures of which they purchased from the firm of Christian Klackner.[113]

FIG. 27
The First Railroad Train on the Mohawk and Hudson Road, 1892–93
Oil on canvas, 42 3/4 x 110 in. (111.1 x 279.4 cm)
Albany Institute of History and Art,
Gift of the Friends of the Institute through
Catherine Gansevoort (Mrs. Abraham) Lansing

27

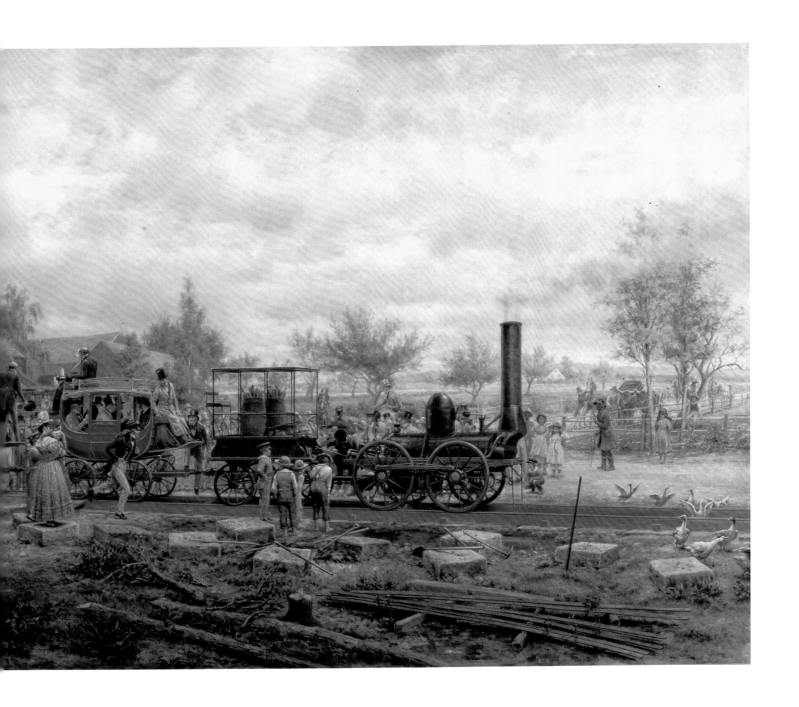

FIG. 28
The Old Clock on the Stairs, 1868
Oil on canvas, 20 3/4 x 16 1/4 in. (52.7 x 41.3 cm)
Collections of Shelburne Museum, Shelburne, Vermont

Nostalgia and Obsolescence

Among Henry's most poignant historical fictions are those that deal with memory and time's passage. As the mantra of advancement once the cornerstone of American identity crumbled, the nation explored temporality and the costs of progress. The rapid transition from an agricultural to an industrial economy after the Civil War introduced competing forms of time—one tied to nature, the other to the machine—that vied for ascendancy by the late 1860s. *The Old Clock on the Stairs*, based upon Henry Wadsworth Longfellow's classic 1845 poem of the same name, manifests this struggle (fig. 28). The verses tell the story of a timepiece located in an "old-fashioned country-seat"— a setting removed from the modern city. "Through every swift vicissitude / Of changeful times, unchanged," the clock witnesses life's happiness and misery without wavering—a stability of which postbellum Americans could only dream.[114] Longfellow's focus upon the passages (birth, marriage, death) over which the clock presides corresponds to premodern understandings of time as circular and regenerating. In a still largely agricultural economy, seasonal rhythms appeared reassuringly intertwined with human existence's own circularity.

Henry articulated this cyclic view of time compositionally by balancing the mirror on the left with the window on the right. The two panes of glowing, reflective glass initiate a reciprocal momentum that is picked up by the arched doorway and the rounded edges of the drop-leaf and tilt-top tables. The stairs contribute to the feeling of circulation, the advancing treads on the left counterbalancing the retreating flight on the right.[115] "Halfway up the stairs,"[116] the grandfather clock anchors these intersecting orbits, its round dial and moon-phase wheel suggesting time's recurring, cosmic dimensions. Juxtaposing the masculine grandfather clock with the elderly "grandmother" in the rear parlor makes explicit premodern time's infinite capacity for reproduction and renewal.

Yet within *The Old Clock on the Stairs*, a strong undercurrent of industrial time erodes premodern, agricultural temporality. The shift from field to factory meant abandoning time tied to nature's cues. Instead of the sun, clocks and bells regimented worker's lives.[117] The grandfather clock's imperious presence, made more commanding by the offset stair runner that visually doubles its already substantial height, alludes to the pervasive temporal regulation of Americans' existence. Longfellow's well-known poem, the lens through which viewers understood the painting, conveys this tyranny in the clock's refrain, "Forever—never! / Never—forever!" Repeated after every stanza, the nihilistic phrase reminds us of the horologe's unceasing drive, its mechanism's eternal plodding so like that of industrial machines. Surging "incessantly" forward, modern time leaves no room for the past, for fear that pausing to look back would still the progressive momentum synonymous with life in an industrial society.[118]

Ultimately, Henry and the viewers who saw versions of the painting at the National Academy of Design in 1869, in Philadelphia in 1875, and at the 1876 Centennial, refused to be subsumed into modernity's temporal regime.[119]

Time may march forward with the new displacing the old, as the elderly woman's newspaper joins the clock in reminding us, but Henry's insistence upon antique furniture, dress, and architecture,[120] and his compositional reinforcement of cyclical temporality, create a space for memory in a modern industrial culture predicated on the pursuit of progress.[121] By making *The Old Clock on the Stairs* such a warm, inviting vessel for antimodern emotions, suffused with glowing colors and rich surfaces, Henry invented a common ground for those disillusioned by industrialization's effects.[122] Far from isolating its adherents in the past, nostalgia vested in paintings like *The Old Clock on the Stairs* inspired social activists to join with laborers in pursuing reforms like the eight-hour workday, intended to reclaim life from industry's dictates by again making people masters of their own time.[123]

But the pain of time's progressive march is tangible in *The Widower* (fig. 29), a depiction of a man's grief at his wife's death. Painted the year of the financial panic of 1873, the canvas also captures Americans' bereavement at such cycles of boom and bust. Also called *The Vacant Chair*, the work simultaneously transmits the sense of loss that still lingered nearly a decade after the Civil War.[124] The trauma of change washes over the elderly man, whose bowed head telegraphs the weight of his emotions.[125] The forlorn mood hovering around the antique furnishings and their aged proprietor, however, expresses a harsh reality: despite progress's disadvantages and sorrows, the alternatives, obsolescence and isolation, were no more appealing. The bifurcation of the canvas between the shuttered, screened, dark, and empty right side and the sunny, open window and newspaper on the left conveys the two available responses: Americans could retreat from reality completely or forestall irrelevance by relating to contemporary society. Despite the sitter's advanced age, Henry positioned the man to the left of the central axis, with the lower half of his body angled toward the open window, aligning him

with it and the newspaper to signal his willingness to embrace life. At the same time, the man's upper body pivots slightly toward the portrait, which he engages in a silent colloquy, his elbow just penetrating the canvas's right side. His dialogue with the past enables him to reckon with the present, and by extension, the life waiting outside his open window. Despite the pervasive, painful reminders of what has been lost, the painting ultimately portrays survival.[126] Through *The Widower*'s golden tonality, Henry acknowledges Americans' regret at the psychic costs of progress, but through deft compositional arrangements, minimizes the specter of obsolescence that was its punishing consequence.[127]

Henry's historical fictions propose numerous solutions for late-nineteenth-century American society's fractured state, offering the past as a means of understanding and navigating the present, and of instilling cohesion. The public obligations assigned to historical reflection permeate Henry's best-known paintings, such as *The First Railroad Train on the Mohawk and Hudson Road* and *The John Hancock House*. However, an examination of *Memories*, a jewel-like canvas that takes retrospection as its subject, reveals that the drive for collective identity entailed compromises some Americans were reluctant to make (fig. 30).[128]

As individual autonomy slowly evaporated in the face of industrialization, Americans began to revise their understanding of the self. Once believed to be independent and cohesive, it was increasingly recognized as being contingent and fragmented in the context of an evermore interdependent market economy.[129] Uncomfortable with the uncertainty now surrounding the self, many people embraced a collective American identity grounded in the nation's past. However, some of those alienated by social and economic transformations clung to historical imagination as a means of preserving a sense of self independent of the drive toward incorporation into an American community. Henry's sitter peruses old daguerreotypes and

FIG. 29
The Widower, 1873
Oil on wood, 8 x 5 ⅞ in. (20.3 x 15 cm)
Smithsonian American Art Museum,
Transfer from the National Museum of American History,
Smithsonian Institution

29

FIG. 30
Memories, 1873
Oil on canvas, 12 x 11 in. (30.5 x 27.9 cm)
Yale University Art Gallery, Partial and promised
gift of Mr. and Mrs. Andrew J. Goodman, B.S. 1968
TR2003.12925.2

(opposite)
Detail of *Memories* (see fig. 30)

30

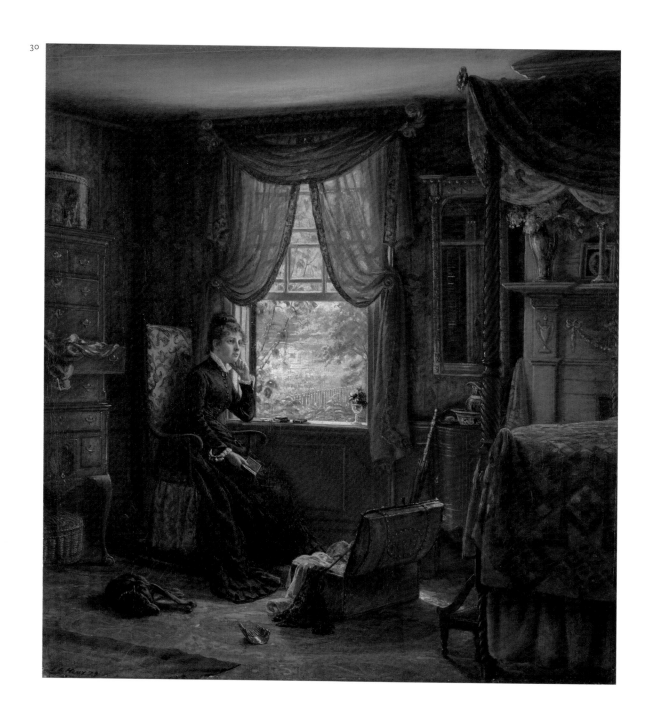

a watercolor-on-ivory miniature in a gold locket—private tokens collected over time that diagram personal relationships to loved ones—using them as touchstones for therapeutic, nostalgic reflection. Like the artist's tintype self-portrait in Revolutionary-era dress, these intimate images permit consolidation of the self through projection into history, but do so by affirming individual rather than national ties. Faced with such a diverse society, it was only through these local connections—articulated in time-honored mementos—that some felt they could make sense of their world. To protect this fragile, resurrected self, the reverie the portraits generate in *Memories* remains private. In contrast to the adjoining, open window whose shape and gold and red colors it shares, the daguerreotype's surface is illegible to viewers. Visible only to the woman, the photograph becomes a portal to an inaccessible inner realm. By keeping it at a remove, Henry insulates her personal history from external obligations or dilution.

Rather than pursuing the national historical narrative so comforting to his countrymen, the artist enmeshed his sitter in "reflective nostalgia," confronting the ambivalence of modern selfhood through the medium of memory.[130] Formal similarities between the woman's top-knot and the cuff and sleeve of a garment spilling from a drawer at left suggest the chaos of her thoughts, a disorder amplified by the open trunk at her feet. Clashing patterns and textures in the room's furnishings augment the sense of physical and psychological dislocation. Packing or unpacking, the woman is caught in a transitional moment, her future, place, and identity as tenuous as her thoughts. Only her connection to the daguerreotype and the room's historic furnishings anchor the woman. As she gazes at each photograph in turn, she externalizes the process of remembrance, composing and revising a story of her past.[131] The narrative she constructs can be reworked to make sense of changing circumstances, allowing her to insure her continuing place in history, and to resist obsolescence.

Likewise, the aged accoutrements with which Henry has furnished her private space provide an additional palimpsest for her memories, allowing her to formulate and amend her own story. Surrendering personal control over the past in order to embrace public history would, some feared, jeopardize the individuality that was the otherwise shaky basis for their sense of self in late-nineteenth-century America. So, surrounded by antiques, the woman explores the past's private properties alone, and lets history's burdens in the present, like her sleeping dog, lie.

NOTES

1 Elizabeth McCausland, "The Life and Work of Edward Lamson Henry, 1841–1919," *New York State Museum Bulletin*, no. 339 (Sept. 1945), 316.

2 Henry to Frank M. Etting, 13 July 1871, p. 33, Frank M. Etting Papers—Artists, Historical Society of Pennsylvania (hereafter HSP), Philadelphia. Protestant Orangemen and Irish Catholics clashed in New York in July 1871.

3 No official records of the artist's service exist. Contrary to Mrs. Henry's assertion that her husband was "too young to enlist as a soldier," he was twenty-three in 1864. Some painters joined military regiments, but others ventured to the front as journalists or simply as observers, unwilling, like many elites toward the war's end, to assume the dangers of taking up arms. Henry later wrote that he went to Virginia "just to see what I could see," confirming that he was not a soldier. See McCausland, 31; also Henry to Edward V. Valentine, 21 Sept. 1870, Valentine Richmond History Center (hereafter VRHC), Museum of the Life and History of Richmond, Richmond, Virginia.

4 Henry to Valentine, 21 Sept. 1870, VRHC. The Byrds were elite Virginia planters. Their most well-known son was William Byrd II, the founder of Richmond, and a diarist who compiled the largest private library in colonial America.

5 For an illuminating discussion of this painting and another version of the subject, *The Old Westover House* (1870, Corcoran Gallery of Art), see Emily Shapiro, "Painter of a Passing Age: E. L. Henry and *The Old Westover House*" (paper presented at the annual meeting of the American Studies Association, 11 Nov. 2004).

6 Sven Beckert, *The Monied Metropolis: New York City and the Consolidation of the American Bourgeoisie, 1850–1896* (Cambridge: Cambridge University Press, 2001), 94–97.

7 Century Association Curatorial Files, Acc. No. 1866.3, Century Association, New York.

8 John E. Clark, Jr., *Railroads in the Civil War: The Impact of Management on Victory and Defeat* (Baton Rouge: Louisiana State University Press, 2001), 1–6.

9 "Adams Express Company," *Harper's Weekly*, 5 Nov. 1864, 709–10. Also, McCausland, 165.

10 See Alan Trachtenberg, *The Incorporation of America: Culture and Society in the Gilded Age* (New York: Hill and Wang, 1982).

11 Beckert, 119, 130–31.

12 See Melinda Lawson, "'A Profound National Devotion': The Civil War Union Leagues and the Construction of a New National Patriotism," *Civil War History* 48, no. 4 (2002), 338–62. Even before its purchase by the club, the as-yet unfinished *City Point, Virginia* was displayed there to promote patriotic sentiment. See "Whittier at the

Union League Club," *The Evening Post*, 13 May 1870, 2; also, "Fine Arts. Reception at the Union League Club—New Pictures," *The New York Times*, 16 Dec. 1872, 2.

13 The phrase comes from a letter Henry wrote to Frank M. Etting, 25 Aug. 1871, Reel P21, fr. 62, Frank M. Etting Papers, HSP, on microfilm from the Archives of American Art (hereafter AAA).

14 A copy of the "Bostonians!" broadside, issued by the Committee on the Preservation of the Hancock House on June 6, 1863, is in the collection of Historic New England, Boston.

15 "The Massachusetts Claim and the Hancock Estate," *Liberator* 29, no. 11 (18 March 1859), 44.

16 Advertisement, *Boston Daily Advertiser*, 30 July 1863, 2.

17 Thomas C. Amory, Jr., *Report of the Committee on the Preservation of the Hancock House*, City Document, City of Boston, No. 56, 1863, 6.

18 Abraham Lincoln, speech, 16 June 1858, in Angela Partington, ed., *The Oxford Dictionary of Quotations*, 4th ed. (Oxford: Oxford University Press, 1996), 421.

19 Arthur Gilman, "The Hancock House and Its Founder," *The Atlantic Monthly* 11 (June 1863), 692–708. For Davis's print, which was reproduced in Robert Sears's *A Pictorial Description of the United States* and elsewhere, see Margaret Henderson Floyd, "Measured Drawings of the Hancock House by John Hubbard Sturgis: A Legacy to the Colonial Revival," in Abbott Lowell Cummings, ed., *Architecture in Colonial Massachusetts* (Charlottesville: University Press of Virginia, 1979), 89.

20 Illustrated in McCausland, 129. If the artist journeyed to Boston to see the building before its demolition, none of his sketches survive. Nor does the painting offer direct evidence that he used measured drawings of the house made before its destruction. See Floyd, 88–102.

21 He omitted, however, the wings that would still have abutted the house's eastern and western ends in the eighteenth century. The east wing was removed in 1818 and the west by 1848. Floyd, 91.

22 By the mid-1860s, freestanding houses were an anomaly even for wealthy urbanites; the costly structures that replaced the Hancock house were attached townhouses. Michael Holleran, *Boston's "Changeful Times": Origins of Preservation and Planning in America* (Baltimore: Johns Hopkins University Press, 1998), 17.

23 Nathaniel Hawthorne, *The House of the Seven Gables: A Romance* (1851; New York: Bantam Classics, 1981), 1.

24 Unrestrained real estate speculation after the war made residential permanence virtually impossible. Holleran, 20, 35–37.

25 Gilman, 706.

26 Holleran, 221–23. Appleton even considered incorporating the building into SPNEA's logo with the motto, "Destroyed 1863." John Deedy, "Preserving Old New England," *The New York Times*, 19 May 1985, sec. 10, p. 15.

27 Anna Wells Rutledge, ed., *Cumulative Record of the Exhibition Catalogues, The Pennsylvania Academy of the Fine Arts, 1807–1870* (Philadelphia: American Philosophical Society, 1955), 97. Although he lived and worked in New York, Henry returned to Philadelphia periodically in search of subject matter or to execute commissions.

28 The catalogue lists the painting as "for sale" with Kulp as the contact. The two had lived together at 702 Chestnut Street. Rutledge, 97; *McElroy's Philadelphia City Directory, For 1859* (Philadelphia: Edward C. and John Biddle, 1859), 311; *McElroy's Philadelphia City Directory, For 1860* (Philadelphia: E. C. and J. Biddle, 1860), 428, 542. See also *American Paintings* (Philadelphia: Schwarz Gallery, 2003), cat. 26.

29 Nicholas B. Wainwright, *Paintings and Miniatures at the Historical Society of Pennsylvania* (Philadelphia: Historical Society of Pennsylvania, 1974), 145.

30 Quoted in McCausland, 49.

31 Etting commissioned Henry to copy a portrait of William Floyd, one of the signers of the Declaration of Independence, to be hung in Independence Hall. The artist also advised Etting about historically appropriate paint and interior woodwork. See Henry to Etting, 12 Jan. 1875, p. 117, Album Relating to the Restoration of Independence Hall, Box 18, Frank M. Etting Papers, HSP; McCausland, 324.

32 McCausland, 160. The stairhall appears in several other paintings: *The Old Clock on the Stairs* (1868; fig. 28), *The Old Back Sitting Room* (1870; unlocated), *An Old Philadelphia Interior* (1870; private collection), *The Weekly Paper* (undated; unlocated), and *Old Woman Reading* (undated; object number 40.17.135, New York State Museum, Albany [hereafter NYSM]).

33 Object number 40.17.1933, NYSM.

34 McCausland, 52. See also photograph by John Moran, object number 40.17.392, NYSM.

35 Thanks to Schwarz Gallery, Philadelphia, for sharing with me a reproduction of the photograph.

36 Henry bought some antiques, including the mahogany corner cupboard pictured in *A Lover of Old China* (fig. 21), at the posthumous auction of Kulp's belongings. See undated clipping advertising the August 29, 1870, sale, Box 1, Edward Lamson Henry Papers, New York State Library, Albany (hereafter NYSL); also, *Catalogue of the collection of Mr. E. L. Henry ... paintings, rare old engravings, colonial furniture, bric-a-brac, to be sold at auction, without reserve ... March 2d* (New York: Ortgies & Company, 1887), 12.

37 See note 32 above.

38 I thank Erin Eisenbarth for her assistance in understanding nineteenth-century Quaker costume. See also *The Workman's Guide*, 2d ed. (1840; Owston Ferry, England: Bloomfield Books, 1975), pl. 15.

39 Elizabeth F. Ellet, *The Women of the American Revolution*, vol. 1 (New York: Baker and Scribner, 1848), 189–201. Henry scratched the title, volume, and page number (198) of his source into the back of the panel painting. For the composition's original title, see "A New Picture. Lady Elizabeth Ferguson," *The Evening Post* (New York), 18 July 1871, 1.

40 Ellet, 197.

41 See correspondence quoted in Scott E. Casper, "An Uneasy Marriage of Sentiment and Scholarship: Elizabeth F. Ellet and the Domestic Origins of American Women's History," *Journal of Women's History* 4, no. 2 (1992), 12, 30 n. 13.

42 Ellet, 192–93.

43 For one such scathing review of a painting for its meaningless glut of detail and lack of believability, see Xanthus, "The Galleries," *The World* (New York), 25 Jan. 1874, 5.

44 Henry to Etting, 27 June 1871, Reel P21, fr. 61, Frank M. Etting Papers, HSP, AAA.

45 Ellet, 198.

46 Henry to Etting, 14 June 1871, Reel P21, fr. 60, Frank M. Etting Papers, HSP, AAA.

47 Henry to Valentine, 21 Sept. 1870, VRHC. See object numbers 40.17.1928, 40.17.1931, 40.17.1935, and 40.17.1937, NYSM.

48 "A New Picture. Lady Elizabeth Ferguson" (see note 39 above).

49 Henry often referred to his collection of historical prints to perfect his renditions. To refine his 1887 depiction of the Lydig homestead (*The Old Lydig House on the Bronx, Near Fordham*; unlocated) so that it would look as it did in the 1830s, he began with a 1790 painting, quizzed the owner after a visit to the property, and provided her with a preliminary drawing to revise to reflect the house's earlier appearance. See McCausland, 184–85.

50 Of an antique sale Henry wrote, "I bought some beautiful things for more than I ought. . . . I am nearly broke in consequence." Henry to Etting, 25 Aug. 1871, Reel P21, fr. 62, Frank M. Etting Papers, HSP, AAA.

51 The high chest appears in another studio photograph, object number 40.17.3027, NYSM.

52 For the flexibility of the "colonial" rubric, see Roger B. Stein, "After the War: Constructing a Rural Past," in Stein and William H. Truettner, eds., *Picturing Old New England: Image and Memory* (Washington, D.C.: National Museum of American Art, Smithsonian Institution, in association with Yale University Press, 1999), 18–19.

53 "A New Picture. Lady Elizabeth Ferguson" (see note 39 above).

54 Gary B. Nash, "Slaves and Slaveowners in Colonial Philadelphia," *William and Mary Quarterly*, 3rd ser., vol. 3 (Apr. 1973), 223–56.

55 The phrase forms part of Henry's inscription on the back of the painting.

56 Caption, stereocard of National Museum exhibits, Box 6, folder 15, Chew Collection, National Museum at Independence Hall Collection, Independence National Historical Park Archives, Philadelphia (hereafter INHPA).

57 "Philadelphia. Labor Agitators Active—Riotous Demonstrations Expected—The Centennial Tea Party," *The New York Times*, 20 Dec. 1873, 3. For a discussion of the instrumentalization of history in establishing a coherent national identity, particularly for immigrants, see William B. Rhoads, "The Colonial Revival and the Americanization of Immigrants," in Alan Axelrod, ed., *The Colonial Revival in America* (New York: W. W. Norton, 1985), 341–61.

58 See receipts for loans and contributions of Chew family relics, 29 Nov. 1873, and 26 June 1876, Box 5, folder 6, Chew Collection, National Museum at Independence Hall Collection, INHPA.

59 The most famous relics were wooden "battle doors" damaged in the Revolutionary War onslaught, which Chew eventually procured. Jennifer Anderson-Lawrence, "The Colonial Revival at Cliveden" (master's thesis, University of Delaware, 1992), 26–27.

60 Ibid., 39. See also Nancy E. Richards, "Cliveden: The Chew Mansion in Germantown" (unpublished manuscript, 1993), 73–74. Cliveden, National Trust for Historic Preservation, Philadelphia.

61 Chew planned to display *The Lafayette Reception* at Cliveden as an interpretive tool for visitors and for his own family's enjoyment, but first he exhibited it publicly in New York in April 1874 at the National Academy of Design, and in Philadelphia at the National Museum as part of the Centennial Exhibition. He had the painting photographed for publication and distribution. See Maria Naylor, ed., *The National Academy of Design Exhibition Record 1861–1900*, vol. 1 (New York: Kennedy Galleries, 1973), 425; Receipt for property deposited by Chews at the National Museum, 29 November 1873 (with later, undated addenda), Box 5, folder 6, Chew Collection, National Museum at Independence Hall Collection, INHPA; Henry to S. Chew, 17 June 1874, Box 224A, Chew Family Papers, HSP.

62 S. Chew to Anne S. P. Chew, undated copy of outgoing correspondence, Box 228, Chew Family Papers, HSP.

63 The photograph is object number 40.17.1575, NYSM.

64 See Chew Family Chronology, 1825, Cliveden, National Trust for Historic Preservation, Philadelphia.

65 Henry to S. Chew, 1 Nov. 1873, Box 223, Chew Family Papers, HSP.

66 Henry to S. Chew, 17 June 1874, Box 224A, Chew Family Papers, HSP.

67 McHenry Howard to S. Chew, 28 Sept. 1875, Box 224A, Chew Family Papers, HSP.

68 Henry to S. Chew, 18 Nov. 1873, Box 223, Chew Family Papers, HSP.

69 Henry to S. Chew, 1 Nov. 1873, Box 223, Chew Family Papers, HSP.

70 Artist William H. Beard drew the headless figure, signing it to distinguish it from Henry's other studies.

71 Henry to S. Chew, 1 Nov. 1873, Box 223, Chew Family Papers, HSP.

72 McCausland, 341.

73 Remnants of the collection, including a dress used as a study for *The Lafayette Reception*, are in the Brooklyn Museum.

74 A Newport resident and amateur historian, Mary Edith Powel lectured and wrote about the city's old buildings.

75 Similar to the "spinning jenny" invented by James Hargreaves in 1770, the vertical or "family" spinner was a means of home yarn production, displaced by the emergence of woolen mills in rural areas around 1840. It could output several strands simultaneously, increasing a household's yield in comparison to the traditional, single-yarn wool or "walking" wheel. See Rabbit Goody, "The Vertical Spinner: An Effective But Short-lived Domestic Machine," *The Chronicle of the Early American Industries Association* 38, no. 1 (1985), 1–4.

76 McCausland, 340.

77 Henry to Etting, 13 July 1871, p. 33, Frank M. Etting Papers—Artists, HSP. An inscription on the back of the painting indicates that after Henry's death in 1919, his widow gave *Spinning Jenny* to a close friend.

78 Henry to Etting, 27 June 1871, Reel P21, fr. 61, Frank M. Etting Papers, HSP, AAA.

79 For more on this phenomenon, see T. J. Jackson Lears, *No Place of Grace: Antimodernism and the Transformation of American Culture, 1880–1920* (New York: Pantheon Books, 1981), 47–74.

80 Henry inscribed the phrase on a photograph of another version of the painting. McCausland, 165. For other discussions of the portrait, see Peter Fuller, "Domestic Tranquility," *Artforum* 16, no. 10 (1978), 52–53; *American Paintings from the Manoogian Collection* (Washington, D.C.: National Gallery of Art, 1989), 76; *A Private View: American Paintings from the Manoogian Collection* (New Haven: Yale University Art Gallery and Detroit Institute of Arts, 1993), 68–71; and John Davis, "Children in the Parlor: Eastman Johnson's *Brown Family* and the Post-Civil-War Luxury Interior," *American Art* 10 (Summer 1996), 51–77.

81 *A Private View,* 68–70. William Gerdts identified the bust in "The Medusa of Harriet Hosmer," *Bulletin of the Detroit Institute of Arts* 56 (1978), 107 n. 7.

82 For an excellent discussion of how the bourgeoisie emerged by distinguishing themselves from those richer and poorer, see Beckert, 8–9, and passim.

83 Beckert, 267–68. See also "The Academy of Music. Its Value as a Social Organizer," *The Brooklyn Daily Eagle*, 15 May 1872, 4.

84 See "Art at the Century Association," *The Evening Post*, 8 Apr. 1872, 4; "Art at the Union League," *The Evening Post*, 10 May 1872, 2; "Fine Arts," *The Brooklyn Daily Eagle*, 1 July 1872, 4; and "Fine Arts. Further Notes of the Exhibition," *The Brooklyn Daily Eagle*, 13 Dec. 1872, 3. On the Bullards' ties to cultural institutions, see Clark S. Marlor, *A History of the Brooklyn Art Association With an Index of Exhibitions* (New York: James F. Carr, 1970); "The Death of Mr. Bullard," *Shoe and Leather Reporter*, 20 Jan. 1881, 97–98; and "The Brooklyn Academy of Music a Paying Institution," *The New York Times*, 15 Jan. 1870, 4.

85 *A Private View*, 70.

86 The rocker may be the one listed in an enumeration of Bullard family property appended to a genealogical chart in the possession of the sitters' collateral descendants. See also D. Hamilton Hurd, comp., *History of Norfolk County, Massachusetts, With Biographical Sketches of Many of Its Pioneers and Prominent Men* (Philadelphia: J. W. Lewis and Co., 1884), 92.

87 On the waterfront's foreign inhabitants and high crime rate, see "Under Brooklyn Heights. Some Strange Sights on the River-Front," *The New York Times*, 9 Jan. 1871, 5.

88 See the Rev. Richard S. Storrs, Jr., *The Puritan Scheme of National Growth. An Oration Delivered Before The New England Society In The City of New York, December 21st, 1857* (New York: Published by the Society, 1858), 5; also "Obituary," *The New York Daily Tribune*, 15 Jan. 1881, 5.

89 "Leaving $25,000 For Charity," *The New York Daily Tribune*, 22 Jan. 1881, 8.

90 See Elizabeth Stillinger, *The Antiquers* (New York: Alfred A. Knopf, 1980), x–xv, 4–21, and on E. L. Henry, 35–41.

91 The image was originally published in Cook's article, "Beds, Tables, Stools and Candlesticks," *Scribner's Monthly* 13 (Apr. 1877), 817. Cook also praised the depicted corner cabinet as "a good specimen of its kind" (818).

92 Drexel to Henry, 5 Sept. 1871, Box 2, folder 1, Edward Lamson Henry Papers, NYSL; Henry to Edward V. Valentine, 11 Feb. 1880, VRHC.

93 A photograph of one such display is object number 40.17.2953, NYSM; also "A Few Antiques from the Loan Exhibition of the Society of Decorative Art," *Scribner's Monthly* 16 (July 1878), 322–25.

94 *Catalogue of the Collection of Mr. E. L. Henry*, 13.

95 Henry to E. V. Valentine, 7 Feb. 1880, VRHC.

96 For a discussion of street lighting and social order, see Wolfgang Schivelbusch, *Disenchanted Night: The Industrialization of Light in the Nineteenth Century*, trans. Angela Davies (Berkeley: University of California Press, 1988); also Peter C. Baldwin, "In the Heart of Darkness: Blackouts and the Social Geography of Lighting in the Gaslight Era," *Journal of Urban History* 30, no. 5 (2004), 749–68.

97 "Yesterday's Disturbances," *The New York Times*, 13 July 1871; and "'The Dangerous Classes,'" *The New York Times*, 16 July 1871, both in Baldwin, 758.

98 For a discussion of this practice, see Rhoads, 342.

99 The phrase comes from a contemporary review of Homer's *Country School*. For further discussions of Homer's school paintings and education, see Nicolai Cikovsky, Jr., "Winslow Homer's *School Time*, 'A Picture Thoroughly National,'" in John Wilmerding, ed., *Essays in Honor of Paul Mellon* (Washington, D.C.: National Gallery of Art, 1986), 47–69; and Margaret C. Conrads, *Winslow Homer and the Critics: Forging a National Art in the 1870s* (Princeton: Princeton University Press, in association with the Nelson-Atkins Museum of Art, 2001), 39–47.

100 See, for example, "The Railroad Men of America: Timothy B. Blackstone," *Magazine of Western History* 12 (July 1890), 299.

101 Cikovsky, 53–54, 57.

102 "At the Academy of Design," *The New York Times*, 10 May 1891, 12. Audiences were able to buy prints of the painting from the firm of C. Klackner, which sold reproductions of numerous works by Henry. See C. Klackner, *Reproductions of the Works of E. L. Henry, N. A., Etchings, Photogravures, Fac-Similes, Platinotypes* (New York: C. Klackner, 1906).

103 "Why Compulsory Education is Attacked," *Chicago Daily Tribune*, 22 Mar. 1889, 4; "The State's Own Schools. Arguments for Compulsory Education," *The New York Times*, 4 Jan. 1890, 5.

104 "The Weak Spot in Our Voting System," *The New York Times*, 3 Nov. 1889, 4.

105 Henry T. Tuckerman, *A Month in England* (New York: Redfield, 1853), 12.

106 William H. Brown, *History of the First Locomotives In America. Popular Edition* (Philadelphia: Barclay & Co., 1877), 3.

107 Tuckerman, 12.

108 A version of the same composition painted in oil on canvas is object number 40.17.2622, NYSM.

109 "Saves Shoe Leather, Methods of Transportation Ancient and Modern," *Chicago Daily Tribune,* 7 June 1893, 11.

110 For a full discussion, see Tammis K. Groft and Mary Alice Mackay, eds., *Albany Institute of History and Art, 200 Years of Collecting* (New York: Hudson Hills Press, in association with Albany Institute of History and Art, 1998), 128–32; also McCausland, 196–98.

111 Correspondence between Henry and the manager of the Baltimore and Ohio's historical exhibition suggests that they may have commissioned the work. Although Henry owned an 1871 copy of Brown's *History of the First Locomotives in America,* his depiction of the DeWitt Clinton more closely resembles the engine's full-scale replica than Brown's silhouette rendering of the cars, reportedly taken from life. See McCausland, 100, 197, 331–33; also "Locomotives of 1831 and 1893," *Scientific American* 48, no. 19 (1893), 294.

112 E. L. H.[Henry], "The Initial Trip of the First Railway Train in America to Carry Passengers—On The Ninth of August 1831," typescript, object file for *The First Railroad Train* (accession number x1940.610.57), Albany Institute of History and Art.

113 James Henry Moser, "Art Topics," *Washington Post,* 29 Mar. 1903, 44; McCausland, 59, 198.

114 Henry Wadsworth Longfellow, *The Complete Poetical Works of Longfellow* (Boston: Houghton Mifflin, 1922), 67.

115 Henry's interest in the stairs' visual impact is amplified in a letter to Etting, in which he enclosed a photograph of the painting, explaining that he had, "colored the 'old clock on the stairs' as it adds to the perspective effect." Henry to Etting, 14 June 1871, Reel P21, fr. 60, Frank M. Etting Papers, HSP, AAA.

116 Longfellow, 67.

117 See Michael O'Malley, *Keeping Watch: A History of American Time* (New York: Penguin, 1990), 30–39.

118 Longfellow, 67; on the nature of modern time and its repression of the past, see Joe Moran, "History, Memory, and the Everyday," *Rethinking History* 8 (Mar. 2004), 51–68.

119 Naylor, 425; *Catalogue of the Centennial Loan Exhibition* (Philadelphia: J. B. Lippincott, 1875), 20; and United States Centennial Commission, *International Exhibition, 1876. Official Catalogue. Department of Art* (Philadelphia: John R. Nagle & Co., 1876), 19.

120 Henry again drew inspiration for the painting's historical setting from Kulp's federal-era stairhall. McCausland, 160, 228.

121 On nostalgia as a form of resistance to the modern idea of time, see Svetlana Boym, *The Future of Nostalgia* (New York: Basic Books, 2001), xv.

122 For a discussion of the antimodern counterculture, see Lears, 59–96.

123 O'Malley, 38–39; Trachtenberg, 89–91; and Timothy Messer-Kruse, *The Yankee International: Marxism and the American Reform Tradition, 1848–1876* (Chapel Hill: University of North Carolina Press, 1998), 34–38, 132.

124 A painting with this title was shown at the Century Association, and another meeting its description was exhibited and auctioned by Edward Schenck's art rooms. "Art at the Century," *The Evening Post,* 3 Feb. 1873, 2; and "Fine Arts. Mr. Schenck's Gallery," *The Brooklyn Daily Eagle,* 26 Feb. 1873, 3.

125 The sadness Henry captured also reverberated in the literary genre of "Old Homestead" stories, which described lives reshaped by Reconstruction-era fluctuations. On the theme of personal loss that the "Old Homestead" tales expressed and the popularity of literature depicting deliverance from grief, see Kathleen Diffley, "Where My Heart Is Turning Ever: Civil War Stories and National Stability from Fort Sumter to the Centennial," *American Literary History* 2 (Winter 1990), 630–32, 635.

126 One strain of Gilded-Age thought held that pain, like that so palpable in *The Widower,* broke through the numbness of modern existence, restoring life by intensifying experience. See Lears, 120–23.

127 On nostalgia as a coping mechanism, see David Lowenthal, *The Past is a Foreign Country* (Cambridge: Cambridge University Press, 1985), 13.

128 For a complete discussion, see the author's "A Private Preserve: Edward Lamson Henry's *Memories,*" *Yale University Art Gallery Bulletin* (2004), 97–101.

129 My assessment of late-nineteenth-century selfhood is indebted to Lears, 35–39.

130 The phrase is Boym's, xviii.

131 In her study of photographs' role in evoking and shaping recollections, Catherine Keenan acknowledges the flexibility of memories generated by looking at pictures. She writes that memory "is a phenomenon that occurs in the present. It refers to the past, but is always shaped by our present perception of the past, omitting and even adding details according to how that perception changes." Keenan, "On the Relationship Between Personal Photographs and Individual Memory," *History of Photography* 22 (Spring 1998), 61.

This catalogue is published on the occasion of the exhibition *Historical Fictions: Edward Lamson Henry's Paintings of Past and Present*, organized by Amy Kurtz Lansing of the Yale University Art Gallery.

EXHIBITION SCHEDULE
24 June–30 December 2005
Yale University Art Gallery, New Haven, Conn.

CATALOGUE
Editor Lesley Baier
Design Jenny Chan/Jack Design
Printer Meridian Printing, East Greenwich, R.I.

TYPESET IN
Chalet, Documenta Sans, Monticello, and Whitman

PHOTOGRAPHY CREDITS
Zeke Martin (cover, fig. 7); Greg Heins (fig. 4); © 2004, Museum of Fine Arts, Boston (fig. 6); © Christie's Images (fig. 9); © Shelburne Museum, Shelburne, Vt. (fig. 21, fig. 28)

Published with the support of
FURTHERMORE: A PROGRAM OF THE J.M. KAPLAN FUND

© 2005 Yale University Art Gallery
P.O. Box 208271, New Haven, Conn. 06520–8271

ISBN 0-89467-959-7
LIBRARY OF CONGRESS CATALOGING-IN-PUBLICATION DATA
Lansing, Amy Kurtz.
 Historical fictions : Edward Lamson Henry's paintings of past and present / Amy Kurtz Lansing.
 p. cm.
 Issued in connection with the exhibition held June 24–Dec. 30, 2005, Yale University Art Gallery, New Haven, Connecticut.
 ISBN 0-89467-959-7 (alk. paper)
 1. Henry, Edward Lamson, 1841–1919—Exhibitions. 2. History in art—Exhibitions. 3. National characteristics, American, in art—Exhibitions. I. Henry, Edward Lamson, 1841–1919. II. Yale University. Art Gallery. III. Title.
ND237.H52A4 2005
759.13—dc22
 2005004382

(front cover)
Detail of *Interior* (see fig. 7)

(back cover)
Detail of *The First Railroad Train on the Mohawk and Hudson Road* (see fig. 27)